WARREN G. HARDING
& the *Marion Daily Star*

D1604300

WARREN G. HARDING

& the *Marion Daily Star*

HOW
NEWSPAPERING
SHAPED A
PRESIDENT

SHERYL SMART HALL

Foreword by Edward Looman, Former Managing Editor, the Marion Star

Charleston · London

THE
History
PRESS

Published by The History Press
Charleston, SC 29403
www.historypress.net

Cover image courtesy of Ohio History Connection.

First published 2014

Manufactured in the United States

ISBN 978.1.62619.412.0

Library of Congress CIP data applied for.

Notice: The information in this book is true and complete to the best of our knowledge. It is offered without guarantee on the part of the author or The History Press. The author and The History Press disclaim all liability in connection with the use of this book.

To all of those Marion Star *employees who worked with "W.G.,"
even in spirit,*

and to Kevin, Brett and Tricia, for their love, encouragement and support.

And to the memory of Scott, who will forever be treasured.

Contents

Foreword

During the summer of 2010, the inaugural Warren G. Harding Symposium was held in Marion, Ohio, to explore the life and impact of President Warren G. Harding. This event brought experts together to examine Harding's presidency, life and the impacts he had on the United States, the world and history in general.

James Robenalt, author of *The Harding Affair: Love & Espionage During the Great War*, said during an interview in advance of the symposium, "I really think it is the time right now to take another look at Warren Harding. My research led me to see pretty clearly that his reputation as a president was totally overwhelmed by scandals, innuendo and mythology that grew up after his presidency."

During his presidency, Warren G. Harding generally was well liked by Americans. After his death, however, wild charges of cronyism and corruption sent him to the bottom of the list of our nation's favorite presidents. This is, of course, a debate that will rage forever.

One thing about President Harding that will never be open for debate is this: he was one of the best newspaper editors of his time and perhaps of all time. He was a true community journalist.

As author Sherry Hall pointed out during remarks from July 2013:

> There is a long, well-worn skeleton key on Mr. Harding's desk in the Harding Home. It's no secret to my co-workers that the key is one of my favorite objects in the house.

That key unlocked the front door of the Marion Star *office building on Center Street. Mr. Harding carried that old key in his pocket for almost forty years, including while he was president. The key says it all about President Harding.*

Harding's tender love of this town was the same care he gave to the state of Ohio as a senator and lieutenant governor. His love for Ohio was a stepping-stone to the love of country.

During Harding's newspaper days, the *Marion Star* historically promoted all kinds of ideas, as well as politicians of both parties, as long as Marion's well-being was the goal.

As Ms. Hall writes in the pages to come, Harding always said he "boomed" Marion, promoted it, stuck by it and loved it. To him, his newspaper's responsibility was to find all of the good in the townsfolk.

Mr. Harding set the standard for what a true community journalist should be. He knew the newspaper was a powerful voice—one that could play a major role in moving a community forward and helping it grow. He used that voice wisely.

I had the pleasure of working with the author (she was Sherry Smart then) at the *Marion Star*. She has done an incredible job of describing Warren G. Harding's days as a newspaperman. The editor-turned-president found pure joy in serving his community.

As is noted in the pages ahead, Mr. Harding was a joiner. He was a member of nearly every fraternal organization in town. That involvement played a key role in his success as a community journalist.

I always considered it a real honor to have followed in Warren G. Harding's footsteps and serve as editor of the *Marion Star*. I was truly honored when Ms. Hall asked me to author the foreword for her work.

Harding was one of the best newspaper editors of his time. He was determined to safeguard the well-being of his beloved Marion, and that determination alone plays a key factor in how newspapering did, indeed, help shape a president.

EDWARD LOOMAN
FORMER MANAGING EDITOR, THE *MARION STAR*

Prologue

When Warren G. Harding placed his left hand on George Washington's Bible and raised his right hand to repeat the presidential oath of office on that clear, chilly March 4, 1921, no one knew that he had a secret. The secret would not damage international relations, bring down his presidency or ignite a war. It was personal, and it was necessary.

Harding stood on the steps of the Capitol in Washington, D.C., looking distinguished and calm in his custom-made morning suit and beaver hat, but he carried a small item in his pocket of which the hundreds of newspapermen, dignitaries and members of the public were not aware. A small, well-worn metal printer's rule—measuring just a couple inches long and wide—was in the president's pocket, just as it had been for thirty-seven years.

The printer's rule, a necessary tool for any newspaperman of Harding's day, was his personal good luck charm, he often said with a smile. But he knew it was more than that. Grasping the rule between his thumb and index finger felt natural, familiar, right. His newspaper, the *Marion Daily Star* in Marion, Ohio, had been his constant companion for all of his adult years—almost a living, breathing being in his eyes, a project that he had nursed from its infancy. It was the anchor that kept him grounded through his political career. It would do the same for him during his presidency.

Issues of the *Star* soon arrived in the White House mail, just a few days after each publication's print date. He trained his lively Airedale terrier, Laddie Boy, to bring the paper to him and eagerly scanned not only the news of his beloved hometown but also the inner workings of

the publication—the headline fonts, the type size, the page layouts, the quality of the photo reproductions. He received regular financial updates from managing editor George Van Fleet. He may not have been seated behind his cluttered, paper-strewn desk in his office at the *Star* building in person, but he certainly was there in spirit.

Now, two years later, in June 1923, President Harding was doing something he dreaded. He was preparing to sell the *Star*. The time was right, he knew, but it still felt odd—like deserting an old friend.

He had received a lucrative offer that he didn't feel he could pass up. Louis Brush and Roy Moore, soon to form the Brush-Moore newspaper chain, were again wooing Harding to sell, as they had been for several years. They were offering $550,000 (roughly $7.4 million in 2013 money). Critics later insisted that the sale price was ludicrous, vastly overpriced for a daily paper in a small midwestern town. There must be a dark side to the story, they said.

The reality was that the *Star* was a gem among newspapers in 1923. Brush and Moore knew what Harding had accomplished, pushing it to the top of the newspaper heap among papers of similar-sized markets across the nation. They also knew they would have something no one else in the newspaper industry could claim: the writing services of the recent president of the United States. The agreement among Brush, Moore and Harding called for Harding to assume an associate editorship at the *Star* once his presidency concluded. With the next presidential election just a year away, and his renomination to the Republican ticket a near certainty, Harding reasonably looked to begin his writing duties in 1929, when he was sixty-four years old.

Selling the newspaper meant he had to alter his will. Attorney General Harry Daugherty, who was serving Harding in a personal capacity in this matter, wanted the terms of the sale spelled out. Because Harding would be leaving later in June 1923 on an eight-week, fifteen-thousand-mile trip across the country and other U.S. territories, Daugherty urged him to take care of this routine business right away. The sale of the *Star* encompassed the sale of stock in gradual increments, with the entire matter concluded by the end of the year.

Some historians lean toward the theory that Harding rewrote his will because he was consumed with an overwhelming feeling of dread, that perhaps he sensed his administration was falling apart or that his recurring chest pains and constant state of exhaustion—which he kept to himself—convinced him that he would not return alive from this

monumental trip. Even his brother, Dr. George T. Harding Jr., is quoted as saying that the president might have sensed the end was near.

The sale of the *Star*, though, was the sole impetus for updating his will, coinciding with Warren's other activities that spring. All of them clearly spoke to the future. In April, he purchased from a cousin the old Harding family farm in Blooming Grove, Ohio. He mentioned to some that he envisioned putting a few golf holes on the gently rolling farm hills and constructing a small cabin as a getaway once his White House years were over. And—perhaps the most pleasing aspect of all—he looked forward to picking up where he had started nearly forty years earlier, scratching out his thoughts for the *Star* on a simple pad of paper.

1

The Big Plunge

Warren Harding entered the world of newspaper ownership twice, both times with the same newspaper and both times in the same year.

In the summer of 1884, Warren heard that the *Marion Daily Star* was up for sheriff's sale—again. Buyers were hard to find, as the *Star*'s record of failure was well known.

Unlike its nameplate, the *Star* was anything but a daily newspaper. It had been billed as a Monday-through-Saturday daily since its inception as the *Marion Daily Pebble* in 1877, but the truth was, it never achieved that status. It was available to Marionites twice a week, weekly or whenever the constantly changing string of owners could manage. During that messy history, two of its young owners, Willis and Harry Hume, brought their father, Sam, into the business and changed the name to the *Star*, perhaps hoping a new name would erase memories of the lackluster *Pebble*.

Convinced that journalism was his life's calling—at least life as an eighteen-year-old envisioned it—Warren badgered his father to buy a half interest. Forty-four-year-old carpenter Benjamin Dempster already anchored the other half. George Tryon Harding needed little convincing to return a vacant lot to the bank for payment and assume half of the *Star*'s debts, which were then placed in Warren's name.[1]

Just after the papers were signed, Warren hopped on a westbound train with the free rail passes he found in the back of a desk drawer at the *Star* office on North Main Street and traveled to Chicago as an observer at the Republican National Convention. That June, the Interstate Industrial

Exposition Building brimmed with energy and excitement as a slate of Republicans, including President Chester Arthur, vied for the presidential nomination. Warren hoped to get a glimpse of his hero, James Blaine. Blaine had been secretary of state and valued advisor to President James Garfield—and was a former newspaper editor. A colorful and enthusiastic speaker, Blaine appealed to young men in Warren's generation.

Blaine captured the nomination on the fourth ballot, and Harding returned to Marion flushed with happiness at being on the fringe of national politics. As the train cars swayed back and forth on their journey to Marion, Warren scribbled several pages of notes about his experiences, with his souvenir Blaine plug hat carefully placed on the seat beside him. Eager to get his words into print, he jumped off the train as soon as it pulled into town and ran nearly all the way to the *Star* office. He pulled up short at the top of the narrow stairway, finding a darkened office and a formidable-looking lock bolting the door. A hastily scribbled note from the sheriff was tacked on the door, stating that the bank had foreclosed on Doc Harding's land used to secure Harding's half ownership. He was out of the newspaper business before he had started.

"During my absence the sheriff found an extra *Star* on his hands," Harding said with a chuckle years later.[2]

At the time, Warren did not find the event remotely funny. He was unemployed and broke—but he was not done with journalism.

He soon walked into the office of the *Marion Democratic Mirror* on the second floor of the Masonic Block on East Center Street looking for work, and publisher Jim Vaughn hired him on the spot. "The salary was seven dollars per week for writing editorials, meeting trains to secure 'personals,' hustling for advertisements, opening the office, scrubbing floors, setting type, making up forms, and even delivering some of the papers."[3]

For several months, Warren's job went smoothly, and he gained valuable insight about how a newspaper office functioned. He kept his opinions to himself and wrote the news. But then Vaughn gave him the assignment of writing an editorial severely critical of Blaine, and Warren embarked on a one-man protest. He wore his Blaine hat into the *Mirror* office. Vaughn asked him to remove it, Harding refused and the young man again was out of work.

Meanwhile, Dempster, who had continued to sporadically publish the *Star*, ran out of money. In November, the *Star* again was in its familiar place on the sheriff's sale docket.

According to Jack Warwick, a native of Harding's boyhood village of Caledonia, Ohio, Harding hatched the plan to buy the *Star* on election night

1884. That night, Democrat Grover Cleveland slipped by Blaine by thirty thousand votes for the presidency, much to Warren's disappointment. In a final humiliation, the Citizens Band, in which founding member Harding played cornet, was hired to play at a celebration for the newly elected Cleveland. Warren, though, soon turned the dismal night on its head.

"The smelly torchlight procession came to an end and the exuberant marchers were crowding into the saloons to yell at the bartenders when Warren G. came along with his cornet under his arm," Warwick said. "The country might be lost, but he still had his appetite. The three of us [Harding, Warwick and John Sickel] went into William Meily's restaurant on Main Street and consumed oysters. It was here that Harding proposed to me that we buy the *Marion Daily Star*. Sickel suggested we make it go three ways."[4]

Harding's business proposal, seemingly spontaneous, really had been banging around in his head since the *Star* slipped out of his grasp the first time. He now realized that he had only been going through the motions during previous attempts at other professions.

For two years, since graduating from tiny Ohio Central College at age seventeen, Harding had been casting about aimlessly for a profession that stirred passion in him. He taught in a one-room schoolhouse north of Marion for a year and hated every minute of it. He was moderately successful at selling insurance and tried to get excited about the idea of studying law as his father wished. Nothing clicked. Only the pungent odor of printer's ink and the feel of soft, white newsprint made his blood race.

To Warren, the chance to buy the *Star* again seemed like destiny. The purchase price amounted to $300 or $450, depending on who was doing the talking and when. Harding himself gave the two amounts at different times. The *Star*'s 1895 Industrial Edition, which summed up the progress of the city, listed the paper's original purchase at $450.[5] During Harding's 1920 presidential campaign, he said the amount was $300.[6]

Various accounts also exist about whose money was used to purchase Harding's share of the *Star*. The most likely story is that Harding's father loaned Warren the money. Others say Harding's former boss, Jim Vaughn of the *Mirror*, gave him the money, apparently confident that the competing *Star* would go down in flames for the final time. Harding himself hinted that he used his savings, but he never really bothered to clear up the story.

Marion marked its sixty-second year of existence in 1884. The few remaining pioneers were feeble now, and the elite of the second generation of Marionites ran the city of nearly four thousand people. Most of these men were in their forties and fifties, and many had fought for the Union

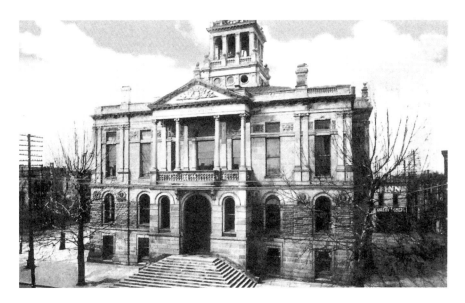

As Marion's new courthouse took shape in 1884, Warren and Jack Warwick struggled to keep the *Star* afloat. The courthouse featured "imported" sandstone from northern Ohio and a red-painted dome. Inside, grand staircases pulled attention up to the murals painted on the ceilings. *Courtesy of Randy and Sandy Winland.*

in the Civil War. They were men who financed the building of Marion's commercial district, organized its banks and major businesses, sought the railroad lines to serve it and propped it up when times were lean. They also made their money from Marion as it grew from infant to toddler.

This group, called the "old guard" by Warren's twenty-something friends, included such men as Amos Kling, Harry True, Henry Hane, C.C. Fisher, inventor Edward Huber, J.S. Reed, Edward Durfee, George Christian Sr., Tim Fahey, Henry Barnhart, attorney Samuel Bartram and William Fies.

Many of them had pushed for the building of a new Marion County Courthouse, now under construction at the heart of the town—Center and Main streets. Like most Ohioans, Marionites considered a regal courthouse to be a mark of legitimacy. This courthouse called for "importing" sandstone from Amherst in northern Ohio and would also include intricate carvings of pioneer faces on the outside and majestic, painted murals in the interior.[7]

When Harding assumed the helm of the *Star*, Marion boasted twenty-two streets—all emanating from the courthouse in a grid pattern. The commercial district stretched roughly two blocks north and south on Main Street and about three blocks east and west on Center Street.

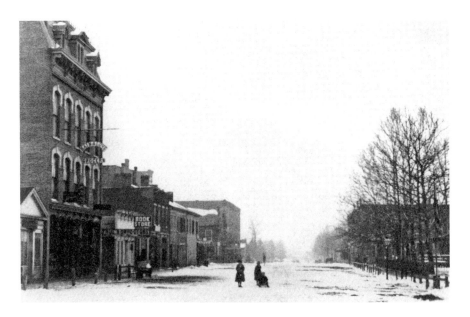

When Warren arrived in Marion in 1882, the village seemed like a metropolis to him. This view shows Center Street on a winter's day. The courthouse is out of view on the right. *Courtesy of Randy and Sandy Winland.*

The compact business district included three- and four-story brick buildings, housing ground-floor businesses such as Strelitz and Son clothiers, W.A. Turney's jewelry store, Harry Weaver's restaurant and Tim Kelly's wholesale liquors on North Main Street. Henry Ackerman's piano store, Fred Diebold's restaurant and Felty & Son meat market anchored South Main. The buildings' second and third floors were occupied by attorneys, doctors, dentists and insurance agents.[8]

Three depots served the rail lines that converged on West Center Street, a most inefficient setup about which the citizens routinely complained. Already, talk centered on how to bring the railroad brass together and have them build a "union" depot.

Fine brick houses from Civil War days and earlier dotted the Marion landscape, such as Henry True's home at the corner of South (Church) and East (State) streets, Judge Ozias Bowen's towering residence near Gospel Hill and the elegant stone house at the corner of Center and West (Prospect) streets owned by the revered Dr. Robert Sweeney. The newer houses were a mix of imposing brick or stone residences and stately wooden Victorian ones, complete with stained-glass windows and elegant turrets.

Warwick, Sickel and Harding—composing the Star Publishing Company—moved into the *Star*'s existing office rooms on the second floor of the Miller Block in downtown Marion, the same rooms Warren had barely glimpsed several months earlier. Marionites in those days referred to business locations by the "block" they were in rather than by the address or street name. "Block" normally did not mean a true city block; rather, it referred to one building usually carrying the investor's name. The Miller Block was on the east side of North Main Street, adjacent to North Street. Most folks called North Street "Railroad Street" for the obvious reason that it followed the east–west railroad tracks cutting through Marion.

The *Star* offices consisted of two small rooms, one facing the street and one directly across the hallway facing the rear of the building. The rear room had an old, black, hand-operated Fairhaven press, enough body type to produce one issue of the paper at a time, some job type and advertising type.[9]

"There never was a place more generally and particularly unfitted, in all its appointments, for a newspaper office than this second floor front and back which we occupied immediately following the adoption of the sick kitten," Warwick lamented, using the "sick kitten" label that he and Harding had given the new endeavor. "Upended, the room in which we worked would have been no taller than the small boy's conception of Alexander the Great. It was long and lean and sepulchral."[10]

From the start, Harding was the front man—the face of the *Marion Daily Star*. He certainly looked the part: six feet tall and slender, with extremely handsome features that people described as Roman. His black hair, gray eyes and dark moustache completed the package. He usually wore a long frock coat in the style of the day. He was charged with gathering the odds and ends of news and spreading the goodwill of the *Star*. That goodwill, he hoped, would translate into a bounty of advertising revenue.

Warwick, at twenty-three, was the eldest statesman of the trio and anchored the mechanical side of the operation. He had worked as an apprentice printer as a teen at the *Caledonia Argus* and most recently in Kansas, so he had a good working knowledge of the machinery. Twenty-year-old Sickel was the silent investor who naïvely jumped into the project when he had an inheritance burning a hole in his pocket and thought the newspaper business would be fun. He had no knowledge of newspapering and little interest in it. Warwick talked Sickel into learning how to set type, but the venture was short-lived. He gave up in a week or two, Warwick said, "not in despair but for fresh air."[11] Journeyman typesetter Claude Drake and a printer's devil completed

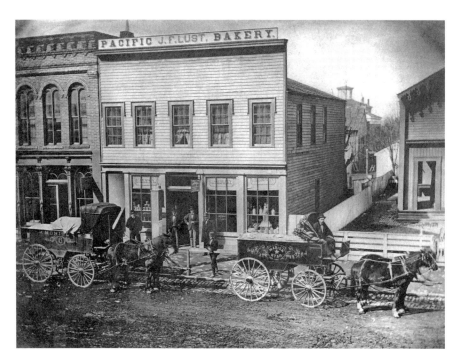

A *Star* delivery wagon makes a stop in front of Lust's Bakery on North Main Street in the 1880s. The wagon most likely was part of Sam Hume's *Star* operation prior to Harding's purchase of the paper in 1884. *Courtesy of Randy and Sandy Winland.*

the staff. Printer's devil was newspaper industry slang for an apprentice who was in the early stages of learning to set type and run a press.

Warren's corner in the front room was typical of the workspaces he would occupy in all three of the buildings housing the *Star* during the next thirty-nine years. "[The desk] looked like a jumble of things, but he knew the location of the papers and clippings stowed away. His early habits as a printer looking after matters about the shop caused him to use a desk but seldom. He acquired the habit of writing with his copy paper perched on his knee, or on the arm of a chair."[12]

Just where the reestablished (as Harding called it) *Star* would align in Marion's journalistic landscape was anybody's guess. The weekly *Mirror* was the Democrats' mouthpiece; the semiweekly *Independent* was Republican. Harding touted the *Star* as independent—but with Republican leanings. Certainly, both Vaughn and *Independent* publisher George Crawford were puzzled by this strange new interloper and prepared for journalistic warfare.

The Shaky Start

²

Warren Harding jumped into producing the *Star* with both feet and probably with eyes closed to all of the obstacles lying before him. The trio's goal was to compile a four-page edition of the *Star*, crank it successfully on the press and get it onto the street for distribution. At that point, it did not really matter what it looked like; it just had to make it from the press to the street.

As was standard, page one contained national and international news, clipped from and attributed to other newspapers. The reader had to run his eyes up and down the vertical columns on the pages, gathering in the hodge-podge of topics. In late November 1884, the odd mix of news contained a *Kansas City Star* account of the discovery of a mummified man and monkey followed by a detailed item about the progress of a sailboat race—stories far removed from the average Marionite's life.

Brief reports about local happenings appeared on page two, mixed in with two- or three-line advertisements. The reader was treated to a recap about a missionary group's meeting followed by items touting the benefits of liver pills and smoked hams. No boldface type or boxes distinguished the advertisements from the news items.

The *Star*'s daily press deadline for the evening paper was noon. By that time, all news had to be gathered, written longhand and then set in type one letter at a time. Editors purchased sets of metal type from type foundries in various fonts and point sizes. Font referred to the style of the letters, such as Bookman Old Style or Helvetica. The point size referred to the size of the

letters, such as eight-point or twelve-point. In newspapering, twelve points roughly equaled one pica. In Harding's day, an editor used a pica pole to measure the point sizes.

Editors valued skilled typesetters, who quickly and accurately built the pages of the newspaper. In one hand, the typesetter held a composing stick. The other hand flew between small bins of *a*'s and *t*'s, as he quickly filled the stick with raised, metal letters to form words and then sentences. He also had to think backward, from right to left, as he worked, since the metal page was the mirror image of the printed page. The sticks matched the width of a column on the newspaper page. After filling a stick, the typesetter pushed the type into the galley page, a wooden form sized the same as the printed page.

Harding and Warwick used newly purchased thirteen-em (a typesetting measurement) printer's rules to line up the type in a column. When the five columns were full in the wooden form, the form was cranked tight, and it was ready for the press. After the press run, the pages had to be quickly dismantled, the pieces of type cleaned and redistributed to their respective bins and the printer rollers washed, and then the process would start all over again the next morning.

Each piece of newsprint (the thin paper used for a newspaper) was large enough to accommodate two pages of the newspaper. Therefore, pages one

Senator Harding shows that, although he is a candidate for president, he still knows how to make up a page for the press in 1920. *Courtesy of Ohio History Connection.*

and four occupied one sheet, and pages two and three were printed on the other side.

Since Harding's first *Star* certainly was nothing to brag about, his readers probably did not read the issue closely enough to pick up on two brief lines of print. A line credited to the most recent *Star* owner, Ben Dempster, simply stated, "I have sold the *Star*." Directly underneath, Harding wrote, "We have purchased the *Star* and will stay."[13]

That brief announcement marked the day when the names of Warren Harding and the *Marion Daily Star* would forever become intertwined.

Prior to cranking the press by hand for the first time, the *Star* staff was well aware that the community expected them to fail. Businessmen stopped Harding on the street, giving unsolicited advice about the folly of a daily newspaper in a small town and shaking their heads about the inexperienced youngsters in charge. It was a joke, they said, and it would be entertaining to watch it implode.

The new editor turned poet in that inaugural issue, addressing the naysayers in a seemingly playful way:

> *Who says that the Star of our village is dead,*
> *That its glory has faded away?*
> *Look, and behold, how bright as pure gold,*
> *It is smiling and dancing today.*

On Saturday, November 29, the *Star* launched an unusually lengthy editorial entitled "Pardon Us." Clearly, Warren had something to say:

> *Thus far, we have, contrary to the usual custom, said nothing in the* Star *about the intentions of the new publishers. Since Sam Hume disposed of the paper, the changes have been varied and numerous. It seems that each succeeding proprietor, by unpopular management, has lost public favor rather than gained it. Under the management of Kell Mount, success was expected but Kelly's ardent administration for a political party carried him too far and his Democratic patrons left him. By the mistakes of others, we should learn the way for improvement. Many times we have been interrogated as to our intentions. "Are you going to sell soon?" "When will the next change occur?" and like question reach us daily. To answer these questions emphatically, we say, "Look for no more changes." Our egotism tells us that if we can't make the* Star *a success, no one can. That the* Star *successfully managed is popular, we are fully assured. The unfavorable circumstances*

under which the present firm first issued a paper were discouraging, but up to the time we write, our subscription list has been increased one-tenth. There is room for more. We believe that we will gain your confidence, at least we hope to merit it, and then we shall certainly obtain your patronage.

Try the Star *and if it doesn't suit you, stop it. We are pleasantly located on the second floor of the Miller block, where we invite you to call and see us. Pardon us for these remarks concerning ourselves and hereafter we will not parade the columns of the* Star *with the publishers' intentions.*[14]

Operating the press by hand was physically tiring, and a number of problems could occur, such as a misalignment of the newsprint rolls and uneven application of ink. The petroleum-based ink not only gave off an overpowering aroma in the unvented pressroom, causing the staff to suffer with headaches and lightheadedness, but it also needed time to dry on the pages so the words would not blur. While the smell of the ink drove Warwick and the devil outside for lungfuls of fresh air, it did not seem to bother Warren. He loved the smell of it and usually had smears of it on his hands and pants.

In just a month, Sickel unsurprisingly backed out of the newspaper scheme, selling his third to Warren, who no doubt borrowed the money from his parents.

Warwick admitted that a lot of responsibility fell on Harding's shoulders at that point: "All that Harding had to do was cover the town for local news, solicit advertising and job work, look after the carrier boys, keep books, help now and then with the typesetting, help to put the paper on the press and devote his spare time to building up the good will of the precarious institution."[15]

Warwick and Harding shared an interest in newspapers, starting when both had afterschool jobs at the *Caledonia Argus*. Warren lived in Caledonia with his family from ages six to seventeen, when the family moved to Marion. Warwick said he and Harding would clip stories from the *Argus* and other newspapers they ran across to stash for their future newspaper, apparently not thinking about timeliness in news reporting. "Caledonia is the town where I first got printer's ink on my fingers," Harding later explained. "I was a devil—as print shop apprentices are known—in the office of the *Caledonia Argus* and learned how to stick type, feed press, make up forms and wash rollers there. To the *Caledonia Argus*, I owe the experience and inspiration that led to my connection with the *Marion Star*."[16]

Harding firmly mandated that the *Star* stick to its daily publishing schedule rather than go to an easier weekly or semiweekly plan. Warren, though,

did not count on the small community's difficulty in adjusting to a daily newspaper. Readers did not see the reason to read a newspaper six days a week. They picked up the *Marion Independent* twice a week or purchased the *Marion Democratic Mirror* once a week, passing them along to other family members and friends. By the time the small number of copies circulated throughout the community, the readers were ready for the next one.

The readers were not the only ones out of step with a daily newspaper schedule. Business owners, too, did not see the necessity in advertising more frequently or in changing the text of an ad more than once every few months. And because advertising money fueled the newspaper, Harding spent an enormous amount of time schooling his elders about the advantages of frequent advertising. It was an uphill battle, one that often left him shaking his head in frustration as he sauntered from Philip Bauer's grocery store to C.C. Pettit's cigar store, trying to shake loose the money pouches of Marion's business district.

Swinging open the door of the *Star* office after one of these rounds of business stops, Warren easily moved back into editor mode. With his scissors, he snipped articles from large stacks of newspapers on his desk, clipping national and international stories that he thought would interest his readers. These newspapers were part of the *Star*'s "exchange list," and piles of newspapers awaited him at the post office and train station each day. The *Star*, in turn, was sent to the newsrooms of these same newspapers. The exchanges were vital, especially for the country editors, who would not otherwise be privy to the editorial views and news of other communities. In 1884, those papers came from metropolitan areas like Cleveland, Pittsburgh and Washington, D.C., as well as smaller Ohio towns like Mansfield, Bucyrus and Sandusky. Using news from the exchanges was perfectly acceptable, as long as editors credited their sources. Plus, it was the only way that a newspaper could earn a decent reputation among its statewide and nationwide peers.

Plucking the local news from the streets of Marion never ended. When Warren slipped into Thomas's barbershop on North Main Street to get a haircut, he quizzed the patrons. He sauntered into the Kerr House hotel on North Main to see if anyone interesting were visiting or doing business in Marion. His attempt to browse the neckties in Strelitz and Son men's clothiers did little to conceal his real quest: picking up a bit of news from talkative customers. On days when he had the money, he grabbed a quick lunch at Will Meily's restaurant near the *Star* office to catch up on the goings-on. In addition to what he scribbled on his notepad with the short pencils

he always kept in his pocket, he counted on Marion's citizens to drop off notecards about who was visiting whom, where they were vacationing, what business trips were planned and who had died or married.

To fill the unquenchable thirst for news, Harding's family was fair game. Within the first month, Harding mentioned that his sister, Mary, was returning home for a vacation as a student at the Ohio School for the Blind in Columbus and that another sister, "Chattie," was back in Marion after a two-week vacation in nearby Galion. Mary suffered from gradually diminishing eyesight, a condition most likely caused by an unseen pituitary tumor.[17] If a buddy from Caledonia stopped by the *Star* offices to chat with the "boys," that chum usually found his name in the newspaper the next day.

Harding found that one of the richest sources of news, and the most socially enjoyable, was the local roller-skating rink:[18]

> *At this time, the roller skating craze was sweeping the country. Marion had a big rink, and it was crowded with skaters every night except Sunday. For getting our paper out on time we generously rewarded ourselves the privilege of faithful attendance at the rink. Of course, we had passes. As a matter of fact, we had all kinds of tickets except meal tickets.*[19]

The *Star* staff's faithful attendance at the skating rink was evident in the frequent coverage in the news columns: "A Thanksgiving matinee will be given by the managers of the skating rink to-morrow afternoon. The Citizens Band will be in attendance. Prices will be the same as in the evening."[20] Or "Ollie Guernsey, the champion fancy skater, [will be] featured at the rink the next three days." The Citizens Band naturally received good notices from the *Star*.

Warwick said the roller-skating rink made the young editors' lives bearable during their first winter, when their workdays often lasted well into the evening and even overnight.

Harding even offered a tongue-in-cheek advice column for his peers, outlining the rules of flirtation at the skating rink:

> *For the benefit of our roller skating friends, we give the following rules for flirtations on skates: One foot in the air means "Catch me"; two feet in the air means "mashed"; hitting the back of your head with your heels, "I'm gone"; one skate in your mouth, "Too full for utterance"; punching your neighbor in the stomach with your left foot, "Kiss me! If you don't I'll hit you!"; suddenly placing yourself horizontally on the floor like the letter "I" indicates, "I am paralyzed."*[21]

Soon, skating rinks popped up in neighboring towns, such as Galion and Bucyrus. Even tiny Waldo, just eight miles south of Marion, talked of building one. Marion's Music Hall installed one to generate business when other events were not taking place. The Huber Manufacturing Company put in a temporary one, inviting the community to celebrate the company's success by taking a turn around the wooden floor. As popular as the rinks were in the 1880s, they nearly disappeared a decade later, replaced largely by the bicycling fad.

The editor daily met with the local doctors, who surprisingly were quite open about who was ailing and who was recuperating from accidents and illnesses. Publishing such information, though, was chancy. "J.G. Leffler's little son, who has been afflicted with diphtheria, is now out of danger. This must indeed be gratifying to Mr. Leffler, who has had so much fatal sickness in his family during the past six months."[22] Mr. Leffler's son died two days later.

Anyone undergoing an operation or extensive medical treatment could expect all of the details to be shared in the pages of any country newspaper, and the *Star* was no exception. Mrs. Dowel of Green Camp, a village west of Marion, underwent a complicated operation performed by the dean of Marion physicians, Dr. Sweney. He was assisted by seven other Marion physicians, demonstrating the seriousness of the endeavor:

> *Mrs. Dowel of Green Camp underwent the horrible operation of ovariotomy yesterday. Notwithstanding the operation was beset with unusual dangers and difficulties, in almost every stage, so much so that the attending physicians twice thought she could not survive it, she came out of it well beyond all expectation and still continues to do so as announced by telegram at 9 o'clock this morning, nineteen hours after the operation. The tumor weighed 47 pounds and some ounces, a pretty good size for a little woman only four feet and eight inches high.*[23]

Doctors were sensitive about receiving due credit for their medical cases. Dr. A.A. Starner thought a conspiracy was afoot involving the *Star* and his fellow physicians to keep his name out of print. Starner wanted an answer from the boss himself—who happened to be serving as a U.S. senator at the time.

Warren's reply dripped with sarcasm:

> *I very much doubt if any organization or society at Marion has been influencing the policy of our paper. I had thought myself, without ever having said anything about it, that there was the excessive use of professional*

> *names in the matter of reporting minor surgical operations. This may be very desirable advertising which any professional man would be justified in accepting, but I have long since learned that the public comes to note these things and it creates a feeling of jealousy in the professional world which is very annoying to any publication office.*[24]

Like any journalist, Warren frequently tracked down rumors that fizzled as news stories, leaving only a blank page in his notepad. "This is the dullest season of the year and yet people expect to see their newspaper filled with news that never transpired," Warren lamented in the columns of the *Star* in the late summer of 1888. "Many an editor is compelled, when the [printer's] devil yells for copy, after scratching his head in vain effort to produce something original, in a fit of desperation to seize his scissors and clip a long article from last year's almanac, which is then produced by the entire country press as an original production. Such is life in newspaperdom."[25]

Within a month of assuming leadership of the *Star*, he was out among his journalistic peers. With his free train passes in hand, he attended a meeting of the Ohio Valley Editorial Association in the southeastern Ohio river town of Gallipolis and then jumped on a train to Chicago the next day to arrange for the purchase of a job press to print event tickets, programs and sales receipts.[26] If he ever were bothered by sidelong glances from the seasoned editors as they sized up the lanky teenager who sauntered into these meetings, he either did not notice or did not care enough to comment.

After the *Star* had been publishing for several weeks, neighboring newspapers noted in their editorial columns the improved look of the paper. While Warren was pleased by such comments and reprinted them in the *Star*, he was not seeing the results in the money drawer. Harding's frustration was hard to ignore. On Christmas Eve, Harding swamped the community with free issues of the *Star* in an effort to draw in more subscribers:

> *This evening the* Star *is sent to a great many persons whose names do not appear on our subscription list. We send these extra copies out as reminder that the* Star *still exists despite the many predictions that the last change would end its existence. There are many who have said "prove your stability and we will patronize you."*
>
> *For one month the present firm has sent out the* Star *better than ever before and the prospects for its future could not be more encouraging. In fact the* Star *has become a necessity and we believe that sobriety and enterprise will make a good paying paper. At the price it is offered there is no one but*

that would not prefer it to our behind hand weekly contemporaries. Read this issue and if you like it send us your name by the beginning of the new year and try it for three months at least.[27]

Despite his bravado, Harding had to be worried about whether the *Star* could indeed keep its head afloat. Still, he was determined to keep going. After just a few months, Harding and Warwick picked up stakes in the Miller Block and moved the *Star* operation to the Fite Building near the northeast corner of Center and East (State) streets. The staff moved into spacious quarters, as compared with the cramped Miller Block. The *Star* now occupied four rooms in a row on the second floor.

"The Fite block location marks the real beginning of the *Star*'s success," Warwick said. "It was here that all possibility of failure was put behind us."[28]

3
The Nemesis

Warren Harding loved the fraternity of the news business. He liked comparing notes with other editors and talking about new presses and newsprint prices, and those conversations and correspondences were not limited to fellow Republican publishers. He found friendly debates with Democratic or Socialist publishers mentally stimulating. To Warren, the calling of newspapering overshadowed the politics of individual newspapers.

"As publisher, Editor Harding always observed the established ethics of the profession," a fellow Ohio publisher wrote in 1922.

> In addition, he adhered to rules of his own. One of these, which he early adopted and from which he never deviated, was that of never-failing courtesy toward his competitors. No unkind, unseemly reference to his contemporary publishers ever appeared in his columns. Although there were occasions when the Daily Star was the object of a competitor's editorials, especially in those days when journalistic encounters were all too common and often vicious, Editor Harding adhered to the same rule which marked his campaign for the presidency—and remained serenely silent.[29]

Not exactly.

As the young publishers attempted to snatch the *Star* back from the brink of extinction in late 1884, one local newspaperman was not in their corner. Warren set sail with the *Star* as an independent newspaper in the day when newspapers tended to pronounce themselves as party mouthpieces. The

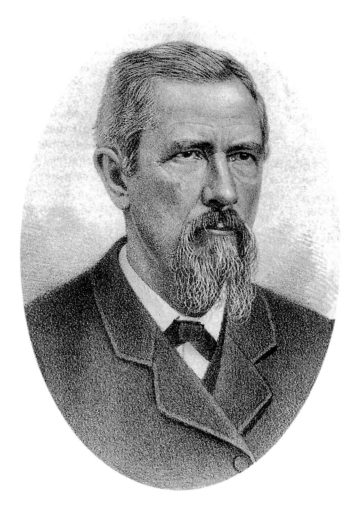

George Crawford, publisher of the *Marion Independent*. Crawford tried his best to clear Marion's newspaper landscape of the *Star*. *History of Marion County, 1883.*

weekly *Democratic Mirror*, as its name suggested, was Democratic in view and piloted by Warren's former boss, Jim Vaughn. Even though Vaughn and Harding had parted ways over Harding's Republican tendencies just after the 1884 fall election, they remained friends. It was a fellow Republican who was to become Harding's personal and journalistic enemy.

George Crawford, fifty-seven, was the editor of the *Marion Independent*, which, contrary to its name, was a Republican organ in a Democratic county. His newspaper was second in circulation to the *Mirror*, and the

Star was a very distant third. Several other smaller newspapers, catering to specific interests, also existed. One, the *Marion Deutsche Presse*, appealed to the Germans in town.

Crawford was arguably the dean of Marion newspapering, having published the *Independent* since 1862. The *Independent* was a descendant of the *Buckeye Eagle*, which had started in Marion in 1844. It went through several owners and several name changes—the *Independent American*, the *Marion Eagle* and the *Marion County Unionist*—until Crawford entered the picture and changed the name to the *Marion Independent*. Crawford owned the paper by himself until 1866, when Samuel Dumble, who had owned one of the paper's earlier versions, purchased a half interest. The company emerged as George Crawford & Co. in 1866.[30]

A native of Steubenville, Ohio, Crawford moved to the central Ohio community of Coshocton with his parents and siblings before landing in Upper Sandusky in Wyandot County, just north of Marion County. He was a lawyer in the days when an apprenticeship of sorts with an established attorney was the standard education. He served as prosecutor for four years in Wyandot County, as well as for four months in the Union army before being discharged with an undisclosed disability.

No one could argue with Crawford's impressive background. In a field of several local newspapers, he had kept the *Independent* flourishing the longest of any of them. His Civil War involvement automatically commanded respect among his fellow townsfolk. He also distantly was related to Colonel William Crawford, who was burned at the stake by retaliatory Native Americans in 1782 in what would become Wyandot County—a well-known account in Marion, which is just twenty miles south of the massacre site. In a strange twist, Harding's lineage also was tied to Colonel Crawford, although more distantly, through Harding's grandmother Mary Ann Crawford.

"As an editorial writer, Mr. Crawford has had an extended experience, and is especially strong in his marshaling of solid facts and arguments, and his utterances carry conviction as those of an earnest and conscientious writer and of one cautious not to exceed the limits of truth and justice in the advocacy of his favorite ideas," the 1883 *History of Marion County* gushed. His pen-and-ink portrait in the history reveals a man perfectly suited to the no-nonsense description: an older man sporting a drooping moustache and goatee, furrowed brows and a steely, piercing gaze, seemingly challenging anyone to take issue with him.

The *Independent* was published each Tuesday and Saturday, at two cents per copy. Crawford was known for his feisty, defensive and arrogant editorials.

He felt keenly that he was the purveyor of truth in the community and that no room existed for other views, even from fellow Republicans.

Crawford was not happy with the outcome of the 1884 fall presidential election, which saw Cleveland slip by Blaine for the presidency. He immediately pointed to voter fraud. "The popular vote on President is a humbug, as one portion of the country is controlled by ballot-box stuffers, false counters, bulldozers and the like," he fumed.[31]

Marion's business community was a mix of Republicans and Democrats. Many of the bankers were Republicans, with the exception of Fahey Bank

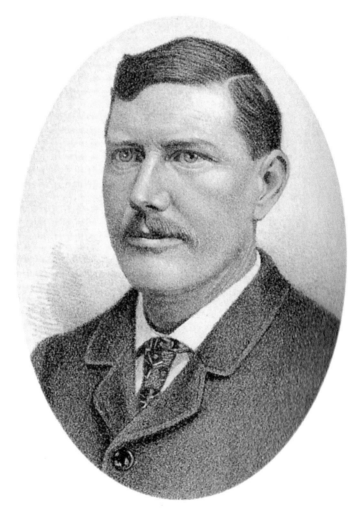

James Vaughn, publisher of the *Marion Democratic Mirror. History of Marion County, 1883.*

owner Tim Fahey. Yet Fahey, along with fellow leaders at the Farmers' Bank and Marion Deposit Bank, saw the wisdom in advertising in both the *Independent* and the *Mirror*. Among Crawford's tightknit group of supporters was Harding's future father-in-law and influential wealthy businessman Amos Kling.

Crawford's favorite target in the 1880s was the *Mirror*, and he often saddled editor Vaughn with all of the wrongs of the Democratic Party. This tactic was typical of the day. Newspaper publishers often exchanged nasty, insulting blasts, and nothing was off limits.

Despite his background in law, Crawford did not shy away from slanderous comments. "Brother Vaughn seems to be troubled about 'the walk' of the editor of this paper. We can walk *straight* at all events," Crawford wrote in November 1884, insinuating that Vaughn was fond of alcohol.

He hit the same theme another time when he wrote, "Vaughn is troubled because the editor of this paper is a Cemetery Trustee. It would be a poor office for a Democrat as there is neither pay nor whisky rations attached to it, nor even a free burial when the Trustee dies."[32]

Crawford largely ignored the *Star* in the first few months of Harding's operation. A single sentence noted the increase of the *Star* news pages from five to six columns, but the *Star*'s purchase of a new job press failed to impress the *Independent*. The usual practice among fellow editors was to make mention of such progress and to extend a wish of good luck, whether they meant it or not.

While not giving the *Star* the time of day in print, Crawford was not above stirring the pot behind the scenes. As he strolled along Main and Center streets, he slipped in a surly comment here and a nasty statement there among shop owners and businessmen about the impending doom awaiting the new *Star* owners. He planted seeds of doubt into the minds of those thinking about spreading some advertising money to the new boys on the block. When the acidic comments reached Harding's ears, he lashed out in print.

"Some man is a willful liar," Harding brashly declared just two weeks into his ownership. "We refer to the man who is telling around that there will be another change in the *Star*. The only change anticipated is that of making the paper better. Persons expecting to damage the *Star* by their silly lies are wasting their breath."[33]

When Warren attempted to pull a chunk of the coveted county legal advertising to the *Star*, Crawford squelched the effort by quietly informing county officials that the *Star* did not qualify to receive the business because its circulation was not countywide, thus it was not a "paper of record." Besides,

he argued, the long-established practice was to split the legal advertising between publications representing political parties, pushing the politically independent *Star* out of the picture.

Warren fought back in the pages of the *Star*:

> *After kindly asking the* Independent *why the* Star *was not a legal advertising medium and waiting for two issues without a reply, we conclude that that dignified organ would prefer to remain silent than notice us in their columns. We are not hurt, however, as we would rather remain in obscurity than to be totally annihilated, and their readers know the* Star *to be their most valuable exchange.*[34]

Among county officials, Harding pushed the idea of competitive bidding for legal advertising. He carried the idea to his editorial column and suggested that the *Independent* did not favor the idea because it feared the *Star*. Crawford offered a thinly veiled threat, warning Warren to back off the issue. "We inform a neighbor that we know a commandment against covetousness and the patronage of the *Independent*, both in advertising and job work is amply sufficient to satisfy us and we do not covet our neighbor's legitimate business," Crawford noted.[35]

Harding cleverly put the *Star* in contention for legal ads when he started the *Weekly Star*, which was meant to circulate specifically in the county. While the *Daily Star* remained independent, the weekly was deemed Republican. Harding, therefore, had satisfied the requirement that a newspaper be of "general circulation throughout the county" and the practice of awarding the ads to papers affiliated with political parties.

Still, Crawford noted, circulation of the *Star* was too small to warrant any serious attention from wise businessmen. "Advertising to pay the advertiser must be backed up by a good circulation. It will not pay to advertise where there is no circulation. This principle is recognized by all intelligent advertisers."[36]

Crawford clearly was puzzled by the *Star*'s status as an independent newspaper, since Harding was openly Republican in his views and in his participation in the local Republican Party. He charged that Harding was playing the Republican card only to gain advertising income. "A Republican paper with Republicanism left out is a queer kind of a "living issue." It is Republican "for revenue only."[37]

Like poking a great sleeping beast with a sharp stick, Warren kept the pressure on Crawford, forcing the veteran editor to take notice of the *Star*. "The *Independent* to-day is the best we have ever seen it. We like to notice the

fact; after all, we won't object to you comparing it with either the daily or weekly *Star* for news."[38]

Warren clearly believed, too, that the *Independent* was not above pilfering news items from the *Star*. "The *Independent* is getting to be a right good local paper but it costs us lots of good hustling, hard work and money to make it so," Warren wrote.[39]

Warren's jabs at the *Independent* were part of the journalism game, essential to establishing credibility and showing he would not be cowed by the bigger operation. Was it also youth speaking in all of its brashness and false bravado? Probably. Was it working? Most definitely, even though Crawford pretended otherwise.

"An [*sic*] useless article is easily detected," Warren wrote in February 1885. "While in a prominent business house yesterday, we found the last four issues of the *Semi-Weekly Independent* lying in a pile unopened. An hour later, a similar sight met our gaze in a leading store, and upon inquiry we found that they were never opened except by the housekeeper who covered her shelves with them."[40]

"It seems to do a certain little puppy a great deal of good to bark at the heels of the editor of this paper," Crawford condescendingly wrote in October 1885. "As it does us no harm and gives the puppy something to do, let him go ahead."[41]

The acrimonious relationship between Harding and Crawford worsened, culminating in the newspaper world's version of a showdown at high noon.

Crawford, like many in Marion, had heard rumors that a black relative lurked somewhere in the Harding family lineage. Some said it was a great-grandmother, others that it was a great-great-grandfather. The facts changed as the stories swirled, but the end result was the same: the Harding family was somehow "tainted" by black blood. In that day and age, and indeed for decades to come, that charge was serious and could doom a family to social disgrace.

The "black blood" rumor had dogged the Harding family since its days in Blooming Grove, the small Morrow County village in which Warren was born. It might have grown from the story that the Hardings supposedly were overly friendly with free black neighbors; it might have its beginnings in a story that an old Harding enemy in Pennsylvania suddenly showed up in Blooming Grove during pioneer days and hurled the accusation for some type of revenge. Regardless of the story's origins, Warren was just six years old when a couple of neighbor boys cornered him, taunting him with racist insults. Warren responded with his fists.

To encounter the same rumors in his adopted hometown was hurtful, but Warren was not surprised that such accusations came from Crawford. "We have no desire to draw the color line on the kink-haired youth that sees fit to use his smut machine only as a receptacle for a low order or adjectives—as nature did it for him," Crawford sneered.[42]

Warren and his father stormed over to the *Independent* office, as the story goes—some say the elder Harding toted a shotgun—and they faced down Crawford and Dumble. The clearly shaken Crawford vowed that the *Independent* would print a retraction.[43]

Warren locked the *Independent* into making good on its promise:

> *Malicious persons, who are attempting to make capital out of an ambiguous paragraph in Friday's* Independent, *that through lying reports of some sneaking scoundrels seems to have application to the editor of this paper, are hereby informed of the positive disavowal of such an application of the article by Messrs. Crawford and Dumble, who have given us their personal assurance that they had no such intention, and will furthermore make a statement of similar nature in Tuesday's* Independent. *And while the subject is up, we notify the retailer of Harding's genealogy, whoever he is, that he is a contemptibly, sneaking, lying dog, who hasn't the sand or nerve to make the statement in a manner that can be traced to him. If he doesn't desire to stand branded as a miserable coward, let him make himself known.*[44]

No one came forward.

Despite the blustering, the confrontation did not come to blows. "A good many people expected to see a fight between the Republican editors here last Friday evening, but were disappointed. Editors fight best at long range and then only with lead pencils,"[45] the *Mirror* dryly observed.

The incident marked a change in how Crawford treated Harding. Still not a fan by any means, Crawford's acidic tongue quieted, and his editorial columns eliminated the subject of the *Star*. He realized too late that he had gone too far. It was not long before the *Star* eclipsed the *Independent*, putting it out of business for good.

4
The *Star* Inches Forward

Warren's first matter of business after moving into the Fite Building was to build a business counter across the combination editorial and business office room, complete with money drawer. "We had to have some place to keep an extra supply of collar buttons, which were forever getting lost in the hustle and bustle of getting out the paper," Warwick wrote sarcastically. "Incidentally, it may be written that Warren Gamaliel had a penchant, or weakness, for counters. They created the impression that business lurked somewhere near."[46]

The duo made no secret of the fact that money barely trickled into the *Star* office. Warren occasionally published notices, warning subscribers and advertisers alike to settle their accounts. The *Mirror* and *Independent* had the same problem in collecting debts, but the *Star* had no financial safety net to fall back on like its larger counterparts.

Harding joked with Warwick about the large money drawer that normally was empty. At the end of each day, Warren quickly scanned the empty drawer, slammed it shut with a flourish and proclaimed, "All paid in, all paid out—books square!"[47]

Harding and Warwick, as owners of the *Star*, often went without pay so they could dole out wages to their staff. The editorial blurbs reflected the state of their lean pocketbooks. Just before Christmas, Harding wistfully wrote, "The *Star* man gazed at the fine turkeys hung out in front of Crow and Lee's across the way, and silently wondered how turkey tasted."[48]

"The *Star* force acknowledges the receipt of a fine selection of cake and other delicacies from the dinner at the wedding of Miss Libbie Davids and George Emerson. Such presents make the printer feel wealthy,"[49] appeared a month later.

Warren, though, was in no danger of going hungry. Although he wanted to support himself entirely on his own, he could not. He lived at his parents' home on East Center Street, erasing any need to pay rent. His mother, Phoebe, made sure that her son—and Warwick—routinely had home-cooked meals.

Warren placed small orders for vital newspaper necessities in order to stretch the *Star* budget. W.T. Cutshall, a salesman for a printer's supply house, met Harding in the first month of the reestablished *Star* and was skeptical that Warren was up to the job:

> *I found young Harding rather reticent, a little hard to approach, but after a half-hour talk he warmed up and talked freely as to his hopes to make the* Star *a paying investment. I gave him information as to how to make a newspaper profitable. Before we left the office I received a small order for paper stock which he most needed—an order of possibly less than a dozen dollars.*[50]

One of Warren's longtime employees, Martin "Lew" Miller, knew firsthand about the scant pickings on payday: "He was often called into the editor's office on the second floor; first, to draw his pay, the next day to loan it to the office, and the next day to receive it back again."[51]

When Warren doled out the wages each week, he was fond of saying, "Here's your insult," as he dropped fresh bills into waiting hands. Warwick said Warren always paid the staff in new money: "There were no germs on the bills we got over the high counter on Saturday night…He would pass over the new stuff with a smile that made Monday morning look like a day to anticipate with pleasure."[52] Warren never forgot those early, lean days, choosing in more profitable times to pay his staff at higher wages than other newspapers.

Despite the constant scramble to keep afloat, Warren kept the paper moving forward. The inherited press did not last long, not because it broke down, but because the bank repossessed it. The *Star* obtained credit to purchase a used cylinder press, and Warren kept it going long after its life should have expired. He fussed with it constantly to coax any additional speed lurking in its creaky hinges and bolts. He experimented with hitching a kerosene engine to the press, hoping to cobble together a form of automation that

would take over the job from aching arms. Warren massaged it and talked gently to it, urging it to keep going. For a time, his unorthodox methods seemed to work:

> He would tinker with this wild thing and talk to it. At times it showed inclinations toward becoming tractable through his handling. Then again it would develop conniptions. Crazed with the heat, it hissed and spluttered and jumped up and down. To me the only time it wasn't dangerous was when it was cold. All of us expected it to blow up, all except W.G. Newsboys shied past it when it was in action. Most of us were ready to run when it began to snap and bark.
>
> There came a day when everybody ran out but the hero. That infernal thing blew up! Not all over, as might have been expected, but the noisiest parts of it blew up. Something burst wide open and all the steam that was in the boiler tried to get out at one and the same time. Some of the newsboys climbed out of the window and clung to the ledge until rescued. Others fell over each other getting down the stairway and to safety.
>
> Where was our hero? He plunged into the blinding steam, stoked the wildcat's fur the right way, and quieted it. But we had to crank the edition off the press.[53]

The time had come to buy a new press. After researching the new models, Warren settled on purchasing a new Babcock press on credit.[54]

Even though he subscribed to a small news service package, he wanted service from the Associated Press. The service in Ohio originated in Columbus, and the Columbus newspapers decided who should receive it. The *Star* was within sixty miles of Columbus, so the Columbus media considered it competition and therefore denied it service. Delaware and Lancaster also were held hostage by the Columbus newspapers.[55] After years of denials, the Columbus papers finally eased their policy and granted service to the outlying papers.

In July 1885, Warren excitedly boasted about the *Star*'s new telephone. "You can call the *Star* by telephoning to number 11. All bits of news will be thankfully received in this way," he wrote, won over to the advantages of being connected to the public.[56] A story circulated in later days that the telephone was the breaking point for Warwick, that feeling the phone was a luxury rather than a necessity, he bailed out of the *Star* ownership.[57] An even less plausible take on the story agreed that Warwick did not want to install

the telephone, but instead of selling his share of the ownership, he lost it to Warren in a poker game.[58]

While true that Warwick sold his share of the *Star* to Warren about this time and stayed on as an associate editor on a salary, a serious squabble over the installation of a telephone seems rather petty in comparison to all of the bumps and bruises the duo had endured while kick-starting the *Star*. What is more logical is that Warwick wanted a steady paycheck, which eluded him as a co-owner. Warren's close friend and White House private secretary George Christian Jr. also said that Warwick's finances were at the root of the ownership change.[59]

The *Star* office was a busy place. Not only did store owners stop in to chat and talk to Warren about advertising, but friends, family and other towns' editors also stopped by to shoot the breeze. *Star* carriers tossed the paper on doorsteps each afternoon, but many of the downtown businessmen crowded around the *Star* counter every day to plunk down their two cents and snatch papers just off the press.

Most people did not know that the *Star* operated a hotel, of sorts, for tramp printers. These men were not "tramps" in the derogatory sense; they were skilled printers who liked moving from newspaper to newspaper after a couple of weeks or several months. Many were just restless souls; others were alcoholics who found it hard to stay long with one employer. Warren loved to chat with them about what was happening at other newspapers, and he let them bed down in a back room.

"Among the tramp printers who stood out among all the rest was Col. Hargot," Warwick said. "Tall and dignified, he always wore a high silk hat that was the worse for wear and a Prince Albert coat. The Colonel was one who didn't like work, but he liked Warren G. because Warren G.'s clothes fitted Col. Hargot."[60]

Just seven months into his ownership, Warren launched the *Marion Weekly Star*. The quarter-page ad announcing the *Weekly Star* overflowed with adjectives: "Marion Weekly Star! Only $1.50 per Year! The Cheapest, Brightest, Newsiest, Most Desirable, Interesting, Entertaining and Instructive newspaper published in Marion County." In the ad, he invited farmers and laborers to try out the publication.[61]

The weekly was supposed to go to the nearby villages of Prospect, Richwood, Green Camp, LaRue and Caledonia, but distribution was difficult. Trains dumped off bundles of the weekly to village newspapers that agreed to be distributors. The distributors would pass them off to a couple of newsboys, who theoretically would bicycle to area farmers and village residents, tossing

the newspapers on doorsteps or placing them on village business counters. But the trains sometimes were late, not arriving until evening. By that time, potential customers in the villages' business districts had gone home for dinner, and the shops were closed for the day. The Richwood newsboy, for example, was hired to swing a newspaper bag full of *Stars* over his shoulder, climb onto his bicycle and ride six miles to the village of Prospect. That plan worked well in fair weather, but rain turned the dirt roads into mud pits.

"On Wednesday evening, the road between here and Prospect was very muddy and it was impossible for the boy to make the trip on a wheel," wrote George Worden, publisher of the *Richwood Gazette* and distributor of the *Star*, to Warren. "On Thursday evening, it was but little better and the boy being about knocked out, it was impossible for us to do anything else. I will drive my vehicle [buggy] to Prospect this p.m. without charge which will even things up."[62]

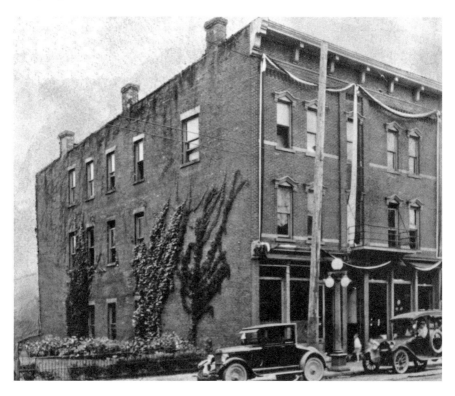

The *Marion Star* newspaper plant on East Center Street, as seen just after President Harding's death. Black-and-white bunting is draped on the building. *Courtesy of Ohio History Connection.*

Despite the distribution problems, the weekly flourished in the county. Warren turned his attention to his newspaper plant, deciding once again to pull up stakes. The move to 229 East Center Street—just across the street from the Fite Building and on the west side of St. Paul's Episcopal Church—would be the *Star*'s last home under Harding's ownership.

In February 1889, Warren and his pressmen dismantled the press on a Sunday, when the *Star* did not publish, and rebuilt it across the street in the newly built Harding Block. The father-son venture put both Hardings further into debt, and still they did not have quite enough money to complete the project. Amos Kling, always one to seize a moneymaking opportunity, invested in the building just long enough for it to debut as the Harding-Kling Block.[63]

The three-story building, with its one-story wing, gave the *Star* operation growing room. It took over the first floor and most of the second and third floors. One second-floor room, just across the hallway from Warren's office, was reserved for Doc Harding's medical office. The *Star* would remain at that address for the next thirty-six years.

5
"Booming" Marion

Harding always said he "boomed" Marion—promoted it, stuck by it, loved it. To him, his newspaper's responsibility was to find all of the good in the townsfolk, in the business propositions, in the growing pains and push all of it to center stage. He had little patience for those citizens who picked apart new ideas and predicted doom for the city.

"Lima merchants have resolved to close up their stores at 7 o'clock every evening except Saturday," Harding wrote, referring to an exchange item from the *Lima (OH) News*. "That's all right, Lima, but Marion merchants cannot wait upon all their customers and close that early."[64]

He roamed throughout Marion County for news, stopping in at the shops in the nearby villages of Green Camp and Prospect to introduce himself, chat with the businessmen and earn their trust. Warren's jaunts energized him, and that always translated into positive stories about the lives of the county villages. He wrote about how well the shops were doing, who had purchased new horses, the health of the crops he viewed in the fields along the way—all signals of Marion County's climb from pioneer crossroads to prosperous hub.

Harding liked what he saw, for example, when visiting the village of LaRue in western Marion County. "McClarey & Sharp were found at their place of business busily engaged in dealing out groceries, of which they have a large and nicely arranged supply," he wrote. "The genial nature of these gentlemen certainly make them favorites with LaRue people, and their shrewdness will warrant them success."[65]

Warwick also backed the pro-Marion policy. "In return for Marion's good will the *Star* took up the work of everlastingly booming the town. We wrote reams of copy, with 'boom' the keynote of every sheet."[66]

Marion's growth from farm town to industrial city mirrored the growth of the *Star*. "My mind is not clear whether I ought to say that the *Star* grew up with Marion or that Marion grew up with the *Star*," said Warwick. "Perhaps it would be fair to say that they grew up together, a fifty-fifty growth, like that of Eng and Chang, the Siamese twins."[67]

In the 1880s, Marion's big issues were tied to infrastructure: producing natural gas, installing sanitary sewer lines, building an electric plant, improving the streets and constructing a waterworks plant.

Marion, like many Ohio towns, was in the midst of the natural gas craze. Local investors put their faith in a successful gas well. Some towns, like Findlay to the northwest, had already struck it rich with their wells. Upper Sandusky, Bucyrus and other nearby cities were having a contest of sorts, to see which would be next to hit it big. Marion already produced artificial gas to power its street lamps, but producing natural gas would cut costs and create additional revenue when gas lines were extended to other nearby gas-dry communities.

While optimistic, Warren tried to put a lid on the excitement, fearing that a gas strike would prompt artificially high property values and an all-out effort to cash in on instant fortunes. He also was fearful that the town would become prey to outside, shady investors:

> *Marion doesn't want any inflated, wild-cat boom, à la Findlay, or Wichita, Kas. The remarkable activity in real estate in the lucky towns that have struck gas is not healthy. When we strike gas, which everybody hopes and many believe that we will, every citizen must not expect to become millionaires. No one questions but that a natural gas find would rightly increase the value of property, but care must be exercised against undue inflation. We don't want any sharks to gamble on us and now is a good time to contemplate a plan of excluding them.*[68]

He need not have worried. Marion's gas boom never materialized, but Warren never faulted the attempt.

In December 1888, a local miracle occurred. Marion flipped the switch on new electric streetlights, making the hand-lit gaslights obsolete. The electric lights hugged arches that stretched across Center and Main streets on all four corners. The Schuyler arc system was ready to be

tested. Under the headline "Marion Illuminated," Warren recorded the momentous event:

> *The era of electric street lighting has come, the inauguration of the improvement occurring Wednesday night. At 7:30 p.m., Miss Della Barnhart, daughter of President Barnhart of the Electric Light Company, made the connection at the station, with the street circuit, and instantly fifteen arcs shed their brightening rays on the street. The effect was charming. The smoky gas lights were doing poor service, and the blazing forth of the electric lights was like a marvelous transformation and the streets presented a truly novel appearance for Marion.*[69]

Warren brushed aside the criticism that just fifteen of the twenty-nine arc lights worked. Testing of the remainder had not been completed. In an attempt to be prudent, Marion leaders decided that the arcs would be illuminated only after December 15 each year and then only on nights without moonlight. The policy naturally led to minor controversies on how much moonlight constituted a "moonlit" night.

As the town began to spread from the Main and Center business district, local leaders saw the need to provide a streetcar system. The debate about

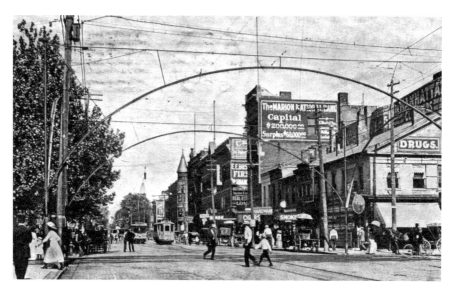

The arches stretching over Marion's central intersection at Center and Main streets were streetlights. They featured the Shuyler arc system and debuted in 1888 to much local fanfare. The arc system replaced the gas streetlights, which had to be lighted by hand each night. *Courtesy of Randy and Sandy Winland.*

the type of system, though, split into factions, with the older businessmen favoring horse-drawn cars and Harding's younger set favoring an electric system. The *Star* urged the leaders to think in modern terms: "Mr. [Bright] Durfee ought not to think of horse cars, they are too old a think for a live booming city like Marion."[70]

Marionites also debated over whether to push to have the town designated as an "official" city. Warren was firmly behind the idea, writing that it was necessary in order for Marion to become "progressive." Such a designation automatically would help the city attract new businesses and would go along with the efforts to improve the infrastructure. To accomplish the mission, the voters approved a ballot issue to annex land into Marion so it would meet the qualifying size.[71]

Warren's efforts sometimes did not pay off, as in the case of how to maintain Marion's pot-holed, disintegrating streets—a common problem for most Ohio towns. Half of Marion's eight-mill tax assessment was for building and repairing streets, leaving little to construct new roads. Some were still dirt; others were macadam. Macadam was a system of layering crushed stone over larger, broken rocks to form a roadway that also would drain some of the surface water. In Marion, limestone was the material of choice, since that was plentiful in area quarries. With a street system grossly underfunded, Warren backed an idea to charge the property owners on each street for its upkeep. The public rebelled, and Warren found he had backed the wrong issue.[72]

Sometimes, the dreams evaporated just as quickly as they had come. Nevertheless, the *Star* saw nothing wrong with promoting all kinds of ideas, as well as politicians of both parties—as long as Marion's well-being was the goal. "We exploited railroads that never got beyond the blueprint and we saw smoke rolling out of the chimneys of factories before the excavations were made for the foundations," Warwick explained. "If a Marion man wanted a State office or a Congressional nomination, be he Republican or Democrat, his cause was the *Star*'s cause against all comers. Our railroads were not all built, the factories did not all come to town nor did our Marion men all get office, but the *Star* never felt ashamed of its work."[73]

By 1890, the *Star* was making an impact. The *Daily Star*'s circulation was 1,100—four years later it would climb to 2,500—and the *Weekly Star* had 1,500 subscribers. The city was keeping pace, with fourteen churches, twenty-seven grocers, three ice cream parlors, seventeen dressmakers, eighteen attorneys and twenty-three physicians. It boasted four foundries—the Huber Manufacturing Company, Marion Malleable, Marion Manufacturing and

the Marion Steam Shovel Company—as well as four banks. The Central Union Telephone Company was up and running, providing phone service within the confines of the city, and Western Union operated its telegraph office on East Center Street to pick up where the telephone service ended. Marion's twenty-five saloons outnumbered its twelve restaurants.[74]

After another five years, the Marion Street Railway Company had completed four miles of service—from West Center Street to the Hocking Valley tracks, from West Center to Kensington (later renamed Garfield) Park, from Main and Center streets to the Marion Cemetery on Delaware Avenue and from State Street to the fairgrounds north of town. Marion was an important stop for five railroads: the Chicago & Erie; the New York Penn & Ohio; the Cleveland, Cincinnati, Chicago & St. Louis (the Big Four); the Columbus, Hocking Valley & Toledo; and the Columbus, Shawnee & Hocking Railway.[75]

The city was nearly finished with paving Center Street from Grand Avenue on the east to the railroad tracks on the west. Marion had improved its paving from crushed limestone to brick, using asphalt filler and stone curbing. The Marion Electric Light & Power Company furnished electric power to a growing number of Marion businesses and residences, and the Marion Gas Company's plant at Columbia and Prospect streets burned tons of coal to furnish artificial gas along five miles of gas mains. The lines for the sanitary and storm sewer system snaked to the Scioto River, where they discharged.[76]

The *Star*, too, puffed up its chest with accomplishment: "The office occupies its own home, a one and three-story structure at 229 east Center street, and has for its newspaper press a famous Cox Duplex Flat-form Perfecting press, such as few interior papers in the country possess."[77]

By 1895, the *Star* routinely published eight daily pages, and its circulation was nearly 2,500. It had compiled sixteen-page newspapers, Warren noted, and "its twelve-page editions have become so common as to attract no comment."[78]

The *Star* pressured the railroads to build a new depot, and Warren personally worked behind the scenes to help make it happen. In 1902, Marionites marveled at the handsome depot complex at the intersection of railroad lines on West Center Street. The *Star* was not done, though. It backed a plan to brick Park Boulevard, as well as to add water and gas taps on the street. The boulevard was billed as a premier developing area in 1907.[79]

Warren did more than just boost new businesses; he also invested in them. Early in his life at the *Star*, Warren started the practice of buying a share or two of stock in new businesses. Not only did each purchase demonstrate his belief in the new venture, but it often led to new advertisers as well. When

Warren Harding purchased this camera for the *Star* in 1895. He tried it out for the first time by shooting photos of a circus parade traveling down Center Street in front of the *Star* building. *Harding Home Collections*.

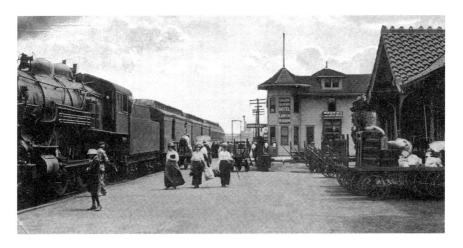

Marion Union Station, built in 1902, was one of the *Star*'s favorite projects to "boost." After years of pushing, Marionites convinced the several railroads serving Marion to pool their money and build a station to serve all of them. The busy station served forty passenger trains a day during Harding's time. *Courtesy of Randy and Sandy Winland*.

he ran for president during Prohibition days, his two shares in a long-expired brewing company from the early 1900s caused a minor ruckus until his habit of purchasing shares was explained.

Warren encouraged Marionites to "buy local" and pushed businesses to advertise more. The Hardings, too, bought their staples in Marion—groceries, house furnishings, stationery. True, Mrs. Harding liked to purchase clothing in Columbus, but she also was a frequent customer at Frank Brothers downtown.

When Warren's political duties called him to Columbus or Washington, he continued to monitor Marion's issues. From 1915 to 1920, he was in the U.S. Senate and received the *Star* in the mail. He communicated constantly with Van Fleet through telegrams and letters. No major purchase, repair or policy occurred without W.G.'s input.

Van Fleet called Warren's attention to a hot issue in town in 1918. Some of the movie theaters wanted to open on Sundays, a day when most small towns closed their business districts. Many thought this was a direct affront to the Sabbath, while others felt that Marion should go the way of other cities in encouraging some business activity on Sundays.[80]

Totally against the proposal, Van Fleet wanted the *Star* to campaign against it. He told Warren that Charles King, vice-president of the Marion Steam Shovel Company, was instigating the idea. King happened to be one of the largest shareholders in the Grand Movie Theater. Ralph Lewis also was a ringleader, saying it would help business in the "fireproof" hotel he was planning to build.[81]

Unlike Van Fleet, Warren had the perspective of distance. He saw the Sunday movie trend gaining popularity along the East Coast, with no dire consequences. "I have never favored the opening of these theatres in Marion on Sunday, because I felt that all of our people had ample opportunity to attend without the Sunday opening," he wrote to Van Fleet. "However, there is such a drift in the direction of tolerating movies on Sunday that I do not think the matter important enough to make a big fuss about it. I would not want the paper to favor Sunday openings, but frankly, I do not see any particular reason for making a vigorous fight against it."[82]

That same year brought Daylight Saving Time to Marion and the rest of the country during the Great War, later known as World War I. President Woodrow Wilson advocated the time change, saying it would allow farmers to be in their fields later in the day, thus producing more wheat and corn for the troops in Europe. Van Fleet could see nothing but resulting havoc in trying to coordinate the railroad schedules, news wire

services and life in general. Warren urged putting the nation's needs first, regardless of personal opinions:

> *Regarding the Daylight proposition, I assume that all the railroads and all the big institutions of the country, including the press associations, will simply move their clocks forward one hour at the time set for the inauguration of daylight saving. I think the law is a fool proposition myself but it has been enacted and I think will be very generally adopted. The thing for us to do is to accept the law as provided and join in the movement. You may use our columns to advocate the Daylight Saving since it is the law and preach what advantages there are in going to work by the artificially advanced time and having that much more of leisure daylight in the evening.*[83]

In 1919, Warren telegraphed Van Fleet from Washington, instructing him on the *Star*'s stance in a Marion road levy issue: "Think you should show full support in good roads meeting. Have written you about attitude of *Star*. We ought support the tax levy proposition provided a definite and efficient program has been agreed to. Otherwise hold aloof."[84]

Although not a veteran himself, Warren always put full support behind American soldiers. He was concerned about the reception the "Marion boys" would receive when they returned from the war in Europe in 1919. He told Van Fleet that when the 166th Infantry, which included the majority of Marion youths, was scheduled to arrive by ship in New York, he would hurry back to Marion to man the editor's desk. Van Fleet could go to New York to meet them and write about their homecoming. Those troops arrived on board the *Leviathan* on April 25, 1919, and Warren made good on his word to return to his editor's chair.[85]

The Man Behind the Pencil

Considering Warren Harding's reputation for being an open, friendly individual, most people—even in Marion—would have been surprised to know that as a young man he was shy and somewhat reticent in everyday conversation. That personal shyness gradually disappeared as his confidence grew. He was not shy, however, when he took pencil to paper.

A newspaper could not survive in those days without publishing opinions, and Warren wrote about everything from presidential races to state issues to local arguments. His writings revealed a man who looked forward to the future of his city and his nation and showed deep, heart-felt interest in the daily struggles of his fellow townsmen.

In the early years, Warren demonstrated an egotism about the *Marion Star*, resorting to aggressive comments at times to perhaps cover his insecurity and youth. His fellow editors dressed him down occasionally, much like a school marm putting her charge in the corner with the dunce hat:

> *The* Star *a day or so ago read the* Mirror *a lecture on its lack of "newspaper courtesy," and the very next day called the* Independent *a "lickspittle organ" and its editor a "lying thief." Brother Harding is a nice young man—and we like him—and he is smart too—most too smart. He talks so much about "newspaper ethics" and makes such nice distinctions between "journalists" and "newspapermen" that we are bewildered at times—but as we said before we like him—we do for a fact. All he needs to do is to tone down the estimate he puts on himself. Not too much of*

course because he is a smart young man and his abilities should not be underestimated, even by himself.[86]

While some interpreted Warren as being an overinflated youngster at work, others saw him merely as someone driving to make a success of his newspaper:

While Warren Harding seems never to have deliberately made an enemy, he had them nevertheless. His success bred them. As his next-door neighbor, Charles C. Fisher, remarked: "No man in Ohio ever defeated and outlived a more persistent, relentless, and unjustified enmity than this young editor in his struggles."[87]

Warren was adamant that the *Star* should report the news, not *be* the news. This policy carried over into Warren's political career, too. His 1899 win for state senator did not merit page one or even its own headline. The editor's victory was buried in the midst of a long, recap story on page three.

Even a somewhat humorous event on that election night did not make the newspaper. On that night, many of Warren's friends crowded into his Mount Vernon Avenue home as they awaited the election results. The wooden front porch was so filled with guests that it began to creak and sag under the weight, soon leaving his friends three feet lower than the front door.

The Hardings were forced to remove the damaged porch, and a newly designed porch was constructed the following summer.[88] That second porch would be center stage for Warren's presidential campaign twenty years later. Certainly, the porch incident would have made the "Local News" column in the next day's paper if it had happened at any other Marion home, probably including a tongue-in-cheek comment calling for Marionites to lose weight before homebuilders were overwhelmed with repair orders.

Warren's love life also was off limits, but an intriguing mention in the early months of the *Star* obviously was written to catch the attention of a particular Marion damsel: "Come, Gentle Anna, what's the use of lingering?"[89]

His marriage to Florence Kling in 1891 earned one paragraph, probably all that the staff dared to write:

It isn't often that the Star *records marriages of its own force, and there might be pardon for unusual notice to the nuptials of the editor, but it is quite sufficient to say that Warren G. Harding and Florence M. Kling were happily married at their own home on Mount Vernon Avenue,*

Wednesday evening at 8:30. Reverend R. Wallace officiated. Quite a pleasant company of friends were present to witness the ceremony and extend congratulations. Mr. and Mrs. Harding were most handsomely remembered by their friends, using this term in the fullest meaning. They leave tonight for Chicago, St. Paul, and the Northwest, expecting to return by way of the lakes. They will be at home to their friends on and after August third.[90]

The popular young editor was a joiner. He was a member of nearly every fraternal organization in town, minus the Freemasons. Sometimes, his enthusiasm for the weekly meetings affected his job performance the next day:

If our dear readers notice any decrease in the amount of local news in today's issue, as may be the case, we may satisfactorily explain the matter right here and state that the Star's proficient news gatherer was induced to take the initiatory degree of the Merry Haymakers last evening. He was not wholly incapacitated from duty this morning, but the elaticity [sic] which characterizes his physical make-up was somewhat taken out of its agile form, which discouraged him from his customary effort to circulate his anatomy among you. We trust he will soon be able to seek his daily news budget.[91]

Warren was invited to card parties, weddings, dances and sleighing groups—anything involving young people in the town. The events always received a detailed accounting in the next day's paper, listing the attendees and decorations and applauding the sumptuous bounty of food. Thirty-some years later, President Harding told of one wedding that earned just a paragraph and still evoked shame on his part. Warren, for the first time, was not on the guest list for a prominent local wedding. He soothed his hurt feelings by giving the event just a few sentences—the bare bones. The wedding note was so unlike his usual generous accounts that the community noticed. Warren was embarrassed that his feelings had gotten in the way of his newspaper. He swore that such an incident would never happen again.[92]

Even though Warren was the voice of the younger generation in town, he was an old soul in his intolerance of bad manners:

Recent experience forces us to cry out again against the most abominable practice of crowding the street corners and holding them to the discomfort and inconvenience of a traveling public generally. We have seen ladies jostled and pushed out into the mud that some great hulk of humanity might

plant his No. 12 brogans in the center of the pavement. We have ourselves attempted to work our way through the crowd of loafers on different corners and have been obliged to use our wits as well as feet nimbly to escape the streams of tobacco juice that would be ejected to better enable the tongue to articulate some would-be smart remarks or witticisms. A lady must resolve to bear patiently the leering looks and smart-alecky comments if she be brave enough to go down Center street to the post office. Why in the name of common decency can not this abominable practice be broken up?[93]

And for a lover of sports, especially baseball, Warren was a bit prudish when it came to boys being boys:

Attention has been called to the dangerous sport many boys indulge in, that of catching and pitching ball. The sport is not dangerous to those who engage in it so much as those that pass the place where such sports are being practiced. Sometimes the boys get in an alley, where a swiftly pitched ball if not caught will fly across the pavement and into the street. If a footman is passing by, he is unaware of the course the wild ball will take and is in great danger of being struck which would not only badly hurt, but seriously injure if he should be struck in some vital part. Will the boys who enjoy such games carefully select some place where pedestrians are not constantly in danger?[94]

Star employees called Warren "W.G.," and he made a point of telling them that they worked "with" him, not "for" him. Warren underscored this team philosophy with action. In the early 1900s, he offered his employees a chance to buy stock in one-fourth of the company. This unheard-of move spoke volumes to his employees about his high regard for them and gave them a personal, vested interest in the success of the *Star*.

From the 1890s, Warren was a popular guest on the summer Chautauqua circuits in both Ohio and upper New York State, where the movement began. The Chautauqua movement was an effort to bring culture and learning to the people, and communities often built Chautauqua pavilions or erected huge tents for the summer attractions. Marion had such a pavilion in Garfield Park.

Warren's favorite topics on which to expound were Alexander Hamilton and Napoleon, although as he became better known in political circles, he spoke about current events. The Chautauqua experience not only broadened his network of connections but also honed his confidence in public speaking. His fan base grew, as did his wallet. The speaking engagements brought

in extra money to the Harding household, which it used for travel. An engagement with the Grand Army of the Republic (GAR) vets in Findley Lake, New York, for example, paid $40 plus expenses. (That $40 would equal about $1,100 in 2013 money.)[95]

The *Star* staff was his extended family. He loaned money here and there to staffers who needed it, even to those moving on to other jobs. He did not put these loans into legal documents; he trusted that his co-workers would repay him. Most of the time, he was right.

"Dear Mr. Harding," wrote Clarke, a printer's devil, from his new home in Washington, D.C.

> *Enclosed find $5 of the amount I owe you, all I can very well spare this week. I will mail the remainder on next Saturday. Have a very nice position here but the work one has to do is something enormous. The town is on the bum as compared with Marion. Every one goes to bed about 9 o'clock and things are about as lively as a graveyard in August.*[96]

Even when the boss was not in town, he made sure that the *Star* employees received Christmas greetings. Ad manager A.J. Myers was especially impressed with his gift of Havana cigars, and Warren reciprocated with thanks for his gift of Camel cigarettes.[97]

He also made sure that his oldest employee, Lew Miller, received his annual Christmas tribute. In a letter to treasurer Henry Schaffner, Warren wrote, "Don't forget that it is an established custom of the *Star* office to give to Louis [sic] Miller a five dollar gold piece on 'Xmas Eve, or the equivalent thereof. I would not want to forget this custom, because Miller is growing old and, in all probability, will not be working for us many years longer."[98]

Warren cared deeply about the well-being of his employees. Birdie Hudson, who had been employed as a combination stenographer-bookkeeper-secretary at the *Star* since about 1907, required surgery and was a patient at Grant Hospital in Columbus. She was under the care of Warren's brother, Dr. George Tryon Harding Jr., who was nicknamed "Deacon" by close friends and family. Harding wrote light letters to Birdie, encouraging her in her recovery: "[Deacon] tells me you are pale and thin and nervous but this is no news to me for you were always that. You would stand no more show of winning a prize in a fat woman show than Henry Schaffner would win a prize in a contest for the best head of hair."[99]

Birdie appreciated the letters. "My Dear Mr. Harding," she wrote from Grant.

The *Star* composing room, circa 1913–15. *Top row, left to right*: composing room foreman W.F. Bull, printer Lew Miller, linotype operators George Tuttle and Elvira Tuttle and printer Fred Buckingham. *Front row, left to right*: printers Frank Dennis, Royal Boger and Wylie Messenger. Bull and Miller started at the *Star* in the 1880s. *Courtesy of Marion County Historical Society.*

> *Thought just to surprise you, I would make an effort to write you a few words in true loving appreciation of your kind, cheerful letters which have meant so much to me. I have the nurse open the letters and then when one comes from you, I read it over and over, each time with greater pleasure. Truly, you have been more than kind and I can't think of one thing more that you could contribute to make the hours more cheerful.*[100]

In a work world without sick leave, Warren paid Birdie her salary while she was hospitalized and recuperating. But fair was fair. Not long after she was back at her desk, Birdie wanted extended time off with pay to watch over her ailing mother. Warren denied this request, writing to Van Fleet, "I should like to treat Miss Hudson according to the Golden Rule, which ought to be exercised in the case of every employee, but we ought to expect her to treat the office in the same manner."[101]

THE MARION STAR,
BY W. G. HARDING,
MARION, OHIO.

Feb. 4, 1909.

Dear Governor:--

The undersigned, being all your friends as well as your employes, holding you and your devoted wife in the highest esteem, send greetings. Hail and farewell. We trust your voyage may be pleasant and that it may bring you increased happiness and health. We pledge ourselves to loyally protect during your absence your interests which are also, we realize ours.
Good bye.and good luck.

As Warren and Florence Harding prepared to set sail for Europe in 1909, *Star* employees wished them well in their own way. *Harding Presidential Papers.*

His employees rarely asked for raises, knowing that Warren would pass along extra money when the *Star* had it. James Ball Naylor, a writer, wrote to Warren to thank him for a Christmas check in 1917:

I enjoy my work on the Star; *and I'm proud of the* Star. *As to my staying with your paper at the present salary, I've had no idea of quitting you. I've felt all the time that you were paying me all you could afford to pay, as print paper prices are; and I've felt, too, that whenever you could afford to pay me more, I wouldn't have to ask for a raise. So we'll let the matter rest right there.*[102]

Sometimes, Warren's faith in people backfired:

Last Wednesday, a busted brother of the pencil-pushing fraternity called in and stated his case, at the same time producing excellent letters of recommendation. He offered to help us, and being quite sympathetic, we gave him $2 and a pencil tablet, and started him for Prospect with great hope. Thursday, he appeared in Caledonia, spending our $2 in a saloon, twenty miles from where, in our innocence, we supposed him getting items, etc. Then we learned we were beaten, and firmly resolved that the next time we got $2 ahead to put it in a savings bank or buy gas stock.[103]

In the early 1900s, Warren introduced his *Star* Creed. This mantra gave voice to the soul of the *Star*, and clearly was based on the Golden Rule. A copy of it was posted on the wall of his office:

Remember there are two sides to every question. Get them both.
Be truthful.
Get the facts. Mistakes are inevitable, but strive for accuracy. I would rather have one story exactly right than a hundred half wrong.
Be decent, be fair, be generous.
Boost—don't knock. There's good in everybody. Bring out the good and never needlessly hurt the feelings of anybody.
In reporting a political gathering give the facts, tell the story as it is, not as you would like to have it.
Treat all parties alike. If there's any politics to be played we will play it in our editorial columns.
Treat all religious matter reverently.
If it can possibly be avoided, never bring ignominy to an innocent man or child in telling of the misdeed or misfortune of a relative. Don't wait to be asked, but do it without asking and above all, be clean and never let a dirty word or suggestive story get into type.

I want this paper to be so conducted that it can go into any home without destroying the innocence of children.

Historians sometimes offer the creed as proof that the *Star* did not criticize anyone, wade in on controversial issues or publish stories about ugly events in the town. The *Star*, they say, merely was a "feel-good" publication.

Nothing could be further from the truth. The *Star* covered all of the usual events in Marion—divorces, assaults, bad business ventures, poor government leadership—just like any other newspaper. It criticized, too:

Every newspaper man and every business man knows that the man who fills a commissioner's chair needs more practical business sense than any officer in the county, and it is a well-known fact that less than one in every five elected to that office have not even ordinary, commendable business judgment. Yet these are the men at the very head of county affairs, who disburse the thousands of dollars of public money every year. There isn't a man in Marion county who would trust his own business affairs in their hands a minute.[104]

Above all, Warren learned that he could not please everyone all the time:

It is worth remembering that no newspaper is printed especially for one person any more than a hotel is built especially to please one guest. People who become displeased with something they find in a newspaper should remember that the very thing that displeases them is exactly the thing that will please somebody that has just as much interest in the paper as they have.[105]

7
The "Human" Editor

Harding had a robust, sarcastic and sometimes cheeky sense of humor. He liked to poke fun at people he liked through inside jokes. Sam Hume, a past owner of the *Star*, was the target in January 1885:

> *The following items were handed us to-day by S. Hume, who felt editorially inclined no doubt. That the* Star *may present some of its old-time style, we express our thanks for them and publish verbatim: "F. Denick who livs 2 mils East of Marion is sufring with fellon on his Right hand. Bro fish is stil Matrimonialey inclind. The Coming Probate Judg J.S. Griswell went home to day to go to bead sick.*[106]

Other observations most likely triggered chuckles among his readers: "We shall say no more hateful things about the bustle, even if it is in style. We scorn to speak of things behind a person's back."[107]

Warren's close friends frequently made the paper. "Will Meily again visited Upper Sandusky last evening. The report that Will is to be married soon and that he went to Upper Sandusky on a bicycle, is probably without foundation."[108]

Sometimes his humor backfired. He created a lasting split with Editor Vaughn when he somehow created a ruse for luring Vaughn to Lizzie Lape's house of ill repute. He then arranged for the police to raid the house, causing Vaughn undo embarrassment. Warren referred to the incident vaguely in print in the next day's *Star*. Vaughn never forgave him.

An 1899 edition of Warren Harding's *Marion Daily Star*. *Harding Home Collections.*

No one could say the *Star* editor was not personally engaged with his community. Warwick described Warren's empathy as the "humanness" of the *Star*. It was the additional comment—that bit of editorializing—that drew readers into the events. "George M. Rice's wife presented him with a big, twelve-pound boy yesterday afternoon. George pronounces the boy a fine one. We smoked."[109]

While he liked to celebrate along with his readers, Warren had difficulty writing about life's tragedies. He knew most of the families in town, and when diphtheria, measles or tuberculosis took a life in one of Marion's households, he felt it personally. Each of these deaths, especially when involving a child, brought back painful memories of events in his own life.

Warren's five-year-old brother, Charley, and his sister Persilla, seven years old, died on the same day—just six hours apart—from jaundice. The image of his mother, Phoebe, nursing the two children as best she could while praying that the illness did not spread to the five other youngsters in the house was seared in his brain. His father was out of town that dreadful day, and thirteen-year-old Warren was his mother's strength. Warren and Phoebe's bond, while already strong, was unbreakable after that day in 1878.

The death of twenty-five-year-old Josie Connors and the critical condition of her friend, Maggie Burke, shook the young editor to the core. Both had

been struck by rolling train cars, with Josie's brother in the job of brakeman on top of the cars:

> *Death in any state brings with it a sadness that shadows its surroundings, but when coming as in this instance, when least expected and to those in the freshness of youth and in so horrible a garb it adds to its shade the blackness of darkness. Any attempt at a description of the anguish and suffering at the Connors house last evening about 9 o'clock would be a failure. In one room lay the mutilated remains of Josie Connors, a mother precariously stricken with grief, and at the same time Maggie Burke in another room of the house awaiting death as a relief with her father and brothers about her.*[110]

Warwick witnessed Warren's inner struggles in balancing life's events:

> *There have been better reporters in Marion than Warren Harding when he covered the town, but we question whether there ever was one more human. Gathering his daily harvest of small stories, he rejoiced in type with the parents of new babies, said pretty things of the newly-weds, jubilated with the jubilant and commiserated with the afflicted.*[111]

Warren easily toggled between the no-nonsense language of the newsman and the wordy, soft prose of the poet, such as in his notes about the romantic goings-on outside Wesley Chapel. The Methodist church was on the southeast corner of East (State) and Center streets, directly across the street from the *Star*'s offices in the Fite Building at the time:

> *Were we inspired, we might write a glowing, perhaps poetic, discription [sic] of the sights visible to the* Star *that are presented on the front and side steps of the M.E. church in this city. Lovers of all ages and cast make that place their rendezvous on pleasant evenings and there sing cantos of love, indulge in the tender embraces that cupid teaches, and happily dream of the wonders of the great firmament while resting between exhausting kisses. True, it is pretty public but the chief actors seem to enjoy it and the lookers-on find it quite amusing.*[112]

Warren had a soft spot for animals. He often spoke out when he witnessed mistreatment: "The man who will drive a team of horses for miles and then hitch them unblanketed to a post to shiver for hours in the cold, is less fit and less likely to get to heaven than the poor dumb brutes are."[113]

Even mishandling a mule, the lowliest of animals in the nineteenth century, tugged at Warren's heart: "If the report we have is true regarding the brutal manner in which J.H. Foster, the drayman, treated his mule this morning, the S.P.C.A. greatly neglects its duty if he is not arrested. It's seldom a mule gets sympathy, but there is a limit to all things."[114]

Warren himself had dogs as pets, and all of them were regular visitors at the *Star*. He brought the large, black Newfoundland he called Senator into his marriage to Florence Kling. When Senator died, personable Jumbo came on the scene. Sometimes described as a mastiff and sometimes as a sled dog, Jumbo's head reached a person's waist. When he patiently sat in the dining room at mealtime waiting for master or mistress to slip him a tidbit, he often rested his head on the table.

Jumbo died in September 1905, and Warren felt strongly that the dog had been intentionally poisoned. Warren pulled out a few pages of *Marion Star* letterhead and wrote sadly to his sister Carolyn Harding Votaw, also mentioning the recent scare of nearly losing their beloved horse, Billy, in a fire:

> *Of course the folks told you about poor Jumbo being poisoned. We miss the dear old fellow very much, and can share your grief over Stephen's [Carolyn's dog] demise. The folks may have told you how narrowly we escaped losing our horse. The Foster livery barn burned and Billy was one of the horses saved. Eight more found alive. If we had lost Billy, I think Florence would have had nervous fits. We think him a fine horse. He would walk into the* Star *office to get a lump of sugar.*[115]

The loss of his Boston terrier in 1913, a death that Warren suspected also was tied to poison, sparked a lengthy editorial in which his grief and anger were evident. "Edgewood Hub in the register, a mark of his breeding; but to us, just Hub, a little Boston terrier whose sentient eye mirrored the fidelity and devotion of his loyal heart," it stated in part. "Perhaps you wouldn't devote these lines to a dog. But Hub was a *Star* visitor nearly every day of the six years in which he deepened attachment. He was a grateful and devoted dog, with a dozen lovable attributes, and it somehow voices the yearnings of broken companionship to pay his memory deserved tribute."[116]

Warren's writing style matched that of other country editors of his day. Considering himself a good but not a great writer, he constructed a personal letter with the same care and thought as he did an editorial. To present-day readers used to sound bites and ten-inch newspaper or brief Internet stories, Warren's wordiness, run-on sentences and circling thought patterns may be difficult to embrace.

He was no different than other writers of his day in referring to African Americans as "Negroes" or "colored" and to immigrants as "foreigners." In his way, though, he stood up for these minorities when he saw disrespect.

To the *Mirror* and *Independent*, which were critical of the *Star* for taking advertising from a recent immigrant, he wrote:

> *Our esteemed contemporaries are giving Marion merchants great long sticks of taffy in the way of advice to people of how and when to deal….Any legitimate advertiser can find space in our columns, if he has the money to pay the sum required, and we play no two-faced racket. If a foreigner can come to Marion and make a good investment in our columns it only proves that it is a good medium that can be profitably used by the very fellows our neighbors are consoling.*[117]

And to those white townsfolk who were bent on harassing an African American church congregation, he had harsh words:

> *The colored people are holding a series of meetings at their church in the North End, and doing what good they can. Services are impeded, however, by the very ungentlemanly white attendants who go there for fun and annoy the minister and members a great deal by their racket. A fitting rebuke was given by the minister the other night when he remarked that "they were welcome only as gentlemen." If this hint is not accepted the police should teach the rowdies a lesson.*[118]

As he climbed in politics, Warren gained critics along with admiring audiences. President Woodrow Wilson did not like Warren's writing or speaking styles, nor did H.L. Mencken, journalist and self-appointed cynical watchdog of American culture:

> *It reminds me of a string of wet sponges; it reminds me of tattered washing on the line; it reminds me of stale bean soup, of college yells, of dogs barking idiotically through endless nights. It is rumble and bumble. It is flap and doodle. It is balder and dash. But I grow lyrical.*[119]

Harding biographer Robert K. Murray said the critics were in the minority:

> *Surprisingly, few contemporaries agreed with Mencken's or Wilson's views. Reporters covering the administration often marveled at Harding's vocabulary and while they quibbled from time to time with his syntax, they thought his choice of words was superb.*[120]

A New Partner

At the age of twenty-four, Harding still lived in his father's East Center Street home, a common living arrangement for unwed children of either gender. And truth be told, he enjoyed living there. He had close, but very different, relationships with his parents. Although he gratefully accepted his father's unfailing faith in him and genuinely enjoyed Tryon's outgoing personality, Warren also had to keep a close eye on Tryon's business dealings. Tryon was a horse trader at heart and loved to swap a piece of this business for a part of that. He fancied himself a business entrepreneur and longed to be a real estate mogul. He bought many properties in Marion, usually could not keep up the payments and then lost them to foreclosure. When his credit soured, he put newly acquired properties in his wife's name. Warren clearly put Phoebe on a pedestal, as did the rest of the Harding family. She was the spiritual backbone of the family, one whose quiet demeanor belied a fierce resolve to protect her children against all comers. She did her best to anchor Tryon.

Tryon and Warren together financed the new Harding Block on East Center Street, which went up in 1888. At first, the newspaper occupied just the first floor of the west side of the building. A photograph shows the small *Star* staff posing proudly by its new headquarters, with Warren sporting a dark, draping moustache and bowler hat looking like it is too small for his large head. At nearly six feet tall, Warren dwarfed the staff members who lounged casually near the doorway.

Marionites climbing the stairway to the second floor could find Tryon's untidy homeopathic office. In the mid-1890s, Phoebe's framed homeopathic

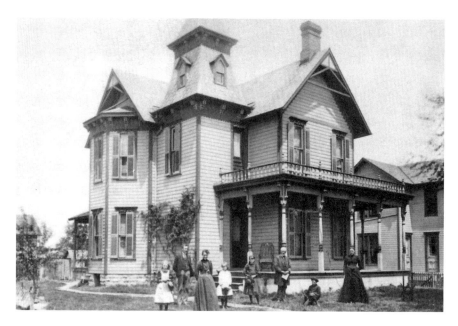

Doc Harding's house, where Warren lived with his parents and five younger siblings. *Courtesy of Ohio History Connection.*

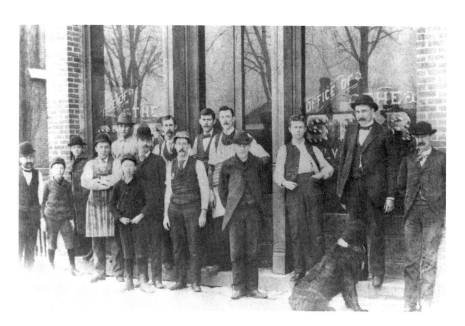

Warren Harding (second from right, sporting a moustache) stands in front of the *Marion Star* offices at 227–29 East Center Street with some of the *Star* staff. The photo probably was taken around 1890. *Courtesy of Ohio History Connection.*

"W.G." nameplate from Warren's office door at the *Star*. *Harding Home Collections.*

license joined her husband's on the wall of the office, as she opened a practice to concentrate on women's and children's health. Other businesses rented the east storefront and upstairs rooms, as the Hardings brought in much-needed revenue.

The *Star* eventually took over the entire building, minus the doctors' (both Phoebe and Tryon) office, as the staff grew and larger presses were installed. The presses were in the front rooms of the first floor, and the composing room was at the rear of the first floor. The stereotyping room was on the third floor.[121]

Warren's second-floor office faced the street. Residents passing by on the sidewalk below frequently glimpsed the soles of Warren's large shoes when the editor rested his feet on the sills of the open window on warm spring days. Warren usually favored this casual writing position, tipping his chair back and balancing a writing tablet on his lap. He always used pencil stubs to write, pulling them out of his pockets along with chews of tobacco. Short pencils were perfect for the roaming reporter, who never knew when he would need to jot down a news item.

His office was unkempt, and he liked it that way:

> *Many a shop talk we had in his upstairs office, a dingy editorial room next door to that in which his father, a practicing physician, had and still has a doctor's office. Memory recalls the lithographs of Lincoln, Grant, Garfield, which adorned the walls alongside those of James G. Blaine, John Sherman and other distinguished men of those days. There were also public sale bills, horse posters, dodgers and other specimens of printing turned out in the* Star *job rooms. During these chats the future president was reading proof, writing and editing copy and giving general directions.*[122]

Marion's young women found Warren extremely handsome, an excellent dance partner and a lively companion but hard to corral into marriage. In his early twenties, he liked to have fun, but he spent most of his time at the newspaper office with little thought of a permanent relationship. And he had nothing financially with which to start a marriage—every dime he had was tied up in the *Star*.

Warren's love life turned upside down when he began romancing Florence Kling after meeting her formally at a dance. The budding romance between the publisher and the daughter of Marion's richest man had all the elements of a good romantic novel: an older, divorced woman interested in a younger, eligible bachelor; intrigue as the couple met secretly to keep their budding relationship out of the public eye; and the angst of star-crossed lovers forbidden to marry.

Florence was twenty-eight when the romance began and already had a colorful past, much to her father's chagrin. Eight years earlier, the gossip mill had run at top speed when Florence eloped with the son of the Klings' next-door neighbor. With an unexpected pregnancy most likely at the root of the event, the marriage of Florence and Henry DeWolfe infuriated and embarrassed their families. Paperwork listing the marriage has not been discovered, whether due to misplacement or disappearance of the old records. Some historians say this points to a common-law marriage rather than an official one.[123] A common-law arrangement, though, would have been a strange choice. Young people from two upper-class families would have handled an unexpected pregnancy the only way they knew how—by marriage. And knowing the explosion of emotions a quick wedding would ignite in their families, they eloped, hoping to escape the thundercloud sure to follow.

The DeWolfes experienced just a short time of wedded bliss, if any. Henry drank too much, disappeared too often and shrank from fatherly duties.[124] Separated about a year after their son Marshall's birth, the DeWolfes then lived very different lives. The Klings took charge of the baby while Florence attempted to start a new life by moving into an apartment and giving piano lessons. The plan did not generate enough money, though, and she moved back home. Florence eventually sued Henry for divorce, gaining the decree and a return of her maiden name in 1886.[125] For the rest of her life, she punished herself for those early events and never addressed the details. No one would have been callous enough to ask. Whether she divulged much of the back-story to Warren is a mystery.

"That short, unhappy period in my life is dead and buried," she stated bluntly in later years. "It was a great mistake. It was my own private affair and my mistake. I did all that was possible to correct it and obliterate it."[126]

Amos Kling, although a self-made, brilliant businessman, was an enigma to his family. His unbending will set the tone for dysfunctional family dynamics. Florence and her two brothers grew up both awed and afraid of him. Florence, Clifford and Vetallis sought his approval, but only criticism, a furrowed brow and a bellowing voice met their endeavors. Their mother, Louisa, brought gentleness into the household, but she was clearly in the background.[127]

The liaison between Warren and Florence indeed was puzzling to many Marionites. While she was a handsome woman, Florence was no shining beauty and certainly was the opposite of the town's younger belles who fluttered their eyelashes and tittered flirtatiously at men's jokes. And simply put, Florence had baggage.

"I know this, however, the town of Marion was deeply interested in this affair between Warren Harding and Amos Kling's daughter," Warwick recounted.

Many of the things I passed in my masculine way were vitalized in the minds of the women of the town and put in circulation on the wings of the morning. There were clandestine meetings—there always are where there are

Florence and her horse, Billy. The Hardings were both animal lovers and were greatly upset when Billy narrowly escaped a fire at the livery where he was stabled. The house appears as it did in the 1890s, with the original wooden front porch. The second, and considerably more famous, front porch replaced the wooden one in 1899. *Courtesy of Ohio History Connection.*

Capulets—and at times the counter in the Star *office, with its two towering ends, furnished protection during short, whispered conversations.*[128]

Speculation since has pointed to greed on Warren's part as the main reason for the marriage. Warren, people surmised, must have had the Kling wealth and social status in mind. Yet anyone living in Marion in 1890 would have known that the theory was baseless; Amos Kling was not about to unclench the death grip on his pocketbook for Warren Harding's benefit. Kling had no use for Harding since the young man had taken over the *Star* six years earlier. Harding knew that Kling despised him and did not care one bit. The feeling was mutual.

Kling never spelled out his objections to Harding, but several reasons are plausible. Kling, as an important Marion investor and businessman, was an old guard Republican. He thus supported Crawford of the *Independent*. He, like Crawford, did not understand Warren's intent with the independent-but-Republican *Star*. All Kling could see was an attempt by the penniless Harding to undermine Republicanism in Marion County.

While appreciating the impact the older generation of businessmen had on Marion, Harding resented the patronizing attitude exhibited toward the "young crowd." The Civil War generation of Kling and Crawford called the shots in Marion, as it did in Ohio politics in general. When Harding began to wriggle his way into local Republican politics, Kling was outraged. The older gent found Harding's presence intimidating, although he admitted that to no one.

Many felt that the Crawford-Kling alliance was the poison. Either Kling had tipped off Crawford or Crawford had whispered to Kling about the "black blood" story that plagued the Hardings. Whoever was the source, Kling was known to spread the story loudly among the town's businessmen. Kling's temper likely flared, too, when he discovered that his two sons, Clifford and Vetallis, as well as his wife, Louisa, liked Harding.

The only thing he controlled was his wallet. In an attempt to cut ties between Warren and Florence, Kling told his daughter that the family money was forever lost to her if she proceeded with the marriage. He made sure that the marriage terms were leaked throughout the town. To his embarrassment, Florence merely shrugged her shoulders and walked out of the large, limestone house at the corner of Center and Mill streets without a backward glance. So Warren knew well ahead of the wedding day that the Kling money was off limits.

Warwick acknowledged Amos Kling's role in Harding's life:

Amos Kling was reputed to be the wealthiest man in Marion and as such was accustomed to having pretty much his own way, because most people let him have it. But Amos Kling did not have his way with his daughter, his only daughter, by the way. Nor did he have his own way with Warren Harding.[129]

The *Star* staff backed the relationship: "The boys in the office were with W.G. in this affair of his heart as they were with him in his newspaper enterprise. They liked Florence Kling, as they liked her after she became the wife of their employer."[130]

The relationship became official with the pair's engagement in 1890, and soon, the sounds of hammers and saws filled the air from a vacant lot at 380 Mount Vernon Avenue. Warren borrowed money and hired skilled contractor Jacob Apt to build a house. Called "Captain" Apt for his Civil War duties, he was a good friend of the Harding family from their Caledonia days. He built many fine buildings in Marion, including the Memorial Block, Forest Lawn School, St. Mary Catholic Church, Union Depot, the Busby Block and residences for the town's upper class.[131] Florence may not have had an ally in her father, but she did in her mother. Louisa Kling helped to pick out and pay for the extras in the home, such

A westward view of Mount Vernon Avenue in Marion after 1900. The Hardings' home is at the right. *Courtesy of Randy and Sandy Winland.*

as the German-made stained-glass windows and the Rookwood pottery tile from Cincinnati surrounding the fireplaces.[132]

Speculation about how Warren and Florence viewed the inner workings of their marriage is merely that. Insight into the relationship comes through a comment here or there in a letter to a third party; there are no existing letters between them. Was the marriage just one of spite toward a bitter old man? It was doubtful that either would throw their lives away just to irritate Amos Kling.

Despite being viewed as an odd match, Warren and Florence built their relationship on shared interests. Florence was drawn to world affairs, business trends and politics, all considered masculine topics at the time. She encouraged Warren's dreams for the *Star* and later permitted him the freedom to chase politics, finding public life as intoxicating as he did.[133]

Florence's keen business mind and accounting talents helped the *Star* financially. She did not edit the *Star* and was not in charge of office policy. Florence may initially have strolled into the office to keep an eye on her husband, as some said, but she quickly rolled up her sleeves and dove into the family business. A naturally nervous person who fussed about details, she tackled areas where she thought the *Star* was losing money or not making enough: circulation and delinquent accounts.

Contrary to some stories, Florence did not initiate home delivery of the *Marion Star*. Warren had already put a system in place that called for delivery boys to act as private contractors. They would deliver the papers, collect the subscription money and reimburse the *Star* at a reduced rate for the papers. The difference between the newspaper cost and the subscribers' payments equaled the carriers' profits. Florence thought the system would work better if the carrier boys were brought "in house," where they were *Star* employees. Warren was only too glad to have her address the circulation department—that meant his plate was just a bit lighter.

"Several times in the early period, I happened in Marion on a Saturday night, and recall seeing her in the stuffy *Star* office adjoining the press room, surrounded by ragamuffin lads, patient in the midst of their boyish clatter, going over their accounts, ironing out their difficulties and giving them advice as to courtesy, collections, delivery of their papers, etc.," said Upper Sandusky editor Sherman Cuneo.[134]

She cleaned up the newsboys' images, mandating that they dress decently, deliver the papers on time to subscribers and treat residents with respect. She paid each with gleaming silver dollars once a week. Sometimes, she paid the subpar workers in pennies and was known to render spankings to

those uttering cheeky comments. The newsboys, in turn, responded to Mrs. Harding's version of tough love, which Warren sometimes softened behind the scenes.

"Florence Harding called me by my first name—and sometimes a name not so endearing," said W.T. Snow, reflecting on his news carrier days. "One

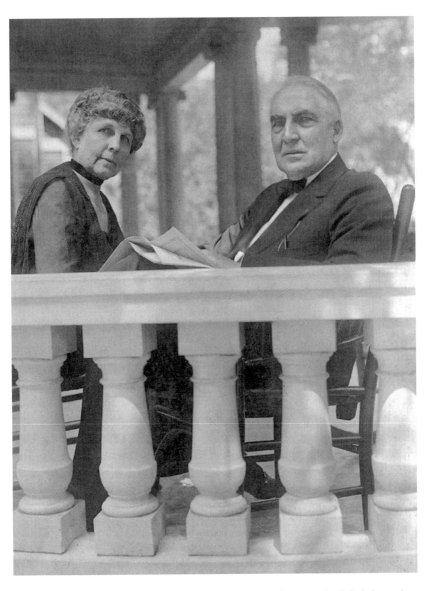

Warren and Florence Harding relax with the *Star* on the front porch of their home in 1920. *Courtesy of Ohio History Connection.*

day she discharged me while in an unfavorable mood, then sent word for me to return and as a special inducement to carry on, gave me my first bicycle. I had taken the matter up with Mr. Harding, who possibly advised her to reinstate me."[135]

Warren applauded Florence's success with the circulation revenue. "The Duchess is a good business woman," he said later, calling his wife by a nickname culled from a popular novel. "When I took hold of the paper, the circulation was managed by contract. She thought we were not getting enough revenue, so I canceled the contract and put her in charge. The first month showed an increase of $200 in the circulation revenues, and until I went to Columbus, to the Legislature, fifteen or sixteen years later, and took her with me, she was the circulation manager of the paper."[136]

Florence took to heart the financial well-being of the *Star*. She knew that handfuls of coins literally did add up. "No pennies escaped her," Warwick said.

> *They may have disappeared before her advent, but none got away and none was unaccounted for after she took over the management of the newsboys. She took them home from day to day, and after the accumulation reached bankable size it was carried downtown and banked. I have seen W.G. marching down to the bank with a gallon of pennies in either hand. I was always curious to know how many pennies made a gallon, but never found out.*[137]

Warren had several bouts of ill health in his twenties. The vague scope of the illness seemingly encompassed fatigue from overwork coupled with untreated high blood pressure and digestive problems. Warren's mother, who had converted from Methodism to affiliation with the Seventh-day Adventist Church in 1879, urged him to recuperate at the Battle Creek Sanitarium in Michigan. Battle Creek, operated by John Harvey Kellogg, was associated with the Seventh-day Adventist Church and offered the comforts of a hotel combined with exercise and carefully regulated diets.[138] Battle Creek, in fact, became a favorite destination for rest and rejuvenation for many of Marion's citizens. After visiting Battle Creek first in 1889, Warren was there four more times in the first twelve years of his marriage. He touted the sanitarium services to others so much that he received special attention from the management.

In 1905, Florence's work at the *Star* ended permanently with the start of serious health problems that would afflict her for the rest of her life. She suffered from nephritis, or kidney disease. The attack in 1905 sent her to Grant Hospital in Columbus for emergency surgery, during which a kidney

was removed. After that, bouts of the disease in her remaining kidney sent her to bed for weeks at a time, with debilitating abdominal pain, swelling in her hands and ankles and extreme exhaustion.

The 1890s brought more than personal change for Warren. The *Star* started to click financially. The weekly *Star* was up to 1,500 copies circulated throughout Marion County, and the daily *Star* boasted press runs of 1,100 each day.[139] Making a jump to a larger subscriber base meant investing in a faster press, which would not only churn out more copies but also accommodate more pages.

He researched presses and talked to fellow editors who were using this one or that one. He kept coming back to a Cox Duplex Perfecting Press, made by the Duplex Printing Company of Battle Creek. He could easily see the Cox presses in action, since they were in operation at the *Toledo Daily Commercial* and the *Canton Repository*. The press was perfect for small-town newspapers: it could print and fold 3,500 newspapers per hour up to eight-page sections. Even the review of the press in a trade journal was favorable: "A pressman of fair ability and intelligence and a boy to take away papers are all that is required."[140]

Harding agreed to the deal in early 1895, arranging to lease the press with an option to buy. Before agreeing to ship the press, Duplex required Warren to prove that he had obtained three insurance policies acknowledging he had a permit for the chemical benzene. The highly flammable and cancer-causing benzene used to lubricate the press could not otherwise be stored at the *Star*.[141]

When Warren had first heard years earlier about a newly invented machine that could set type automatically, he was skeptical that it could replace a talented printer setting by hand: "It is claimed that a successful type setting machine has at last been put in operation. We go right smart on machinery, but we want to see it trot around the office hunting sorts and stealing leads before we take much stock in it."[142]

A decade later, he was eager to investigate the latest version of this new machine, called a linotype, which was the talk of the newspaper industry. He did his homework, visiting newspapers using the new linotype machines and corresponding many times with the Mergenthaler Linotype Corp. The $500 yearly lease price per machine ($13,800 in 2013 money) was a major investment, but Harding saw the savings in efficiency and the opportunity to print newspapers with more pages and special editions. He ordered two machines in early 1897[143] and became part of a major turning point in newspapering that cut costs, resulting in cheaper subscriber prices. Because

The pressroom at the *Marion Daily Star* on East Center Street. The bank of linotype machines is in the back of the room, and the tables holding the page forms are in the foreground. *Courtesy of Randy and Sandy Winland.*

of the revolution of the linotype, more books, magazines, newspapers and other publications could be economically printed and put into the hands of the public.

The linotype did just what its name suggested: it produced line after line of type, quickly filling a column. The linotype completed the work routinely done by six skilled printers setting type by hand. The cogs, teeth, belts and cylinders moving at many different speeds created a deafening, metallic symphony of whirring, clanking, clanging and tinkling. The machine was not for the faint of heart; it was seven feet tall, weighed two tons, had five thousand moving parts and was dangerous. The machine spewed molten metal, composed of lead, tin and antimony heated to 550 degrees Fahrenheit, to cast the type; a blockage or a slight slip of a part meant the steaming metal liquid could stream onto the operator, causing severe burns. It could also trap fingers or an arm if the operator lost focus for just a few seconds.[144]

Skilled linotype operators could walk into any newspaper and claim a job. They had completed training courses, most likely at the Mergenthaler

Corporation itself, which also included instruction in invaluable machine maintenance and repair. Competency, though, required several months, or even years, on the job.

Warren sent printer J.F. Harris to New York for instruction, paying for room, board and transportation for twenty-two days. Harris was the second *Star* printer to go through the training. The first printer flunked the course. Mergenthaler president Philip Dodge wrote to Harding himself about Harris's progress.

"Has made very good progress for the amount of time spent here but would need more instruction before being thoroughly capable of handling a plant of machines. He is careful and uses good judgment in handling machines, which goes a long way toward keeping one in order."[145]

The *Star*'s staff grew during the 1890s, with additional reporters, pressmen and business manager Myers on board. Warren also hired a managing editor who would be crucial to the *Star*'s success for the next twenty-five years. George Van Fleet, an attorney, was the competent editor who would keep the *Star* churning nicely while Harding was away from the office on vacation and, eventually, in political office.

Despite the long hours, constant headaches concerning malfunctioning printer rollers and the news service squabbles, the life of publisher Harding was quite pleasant. He and Florence loved to travel, as their honeymoon trip to Chicago, St. Paul and the Northwest proves. They stepped up their travel as the years went on, largely because of the free railroad passes Warren obtained in exchange for advertising the railway timetables in his newspaper. The rail passes were a perk every editor embraced, permitting him to travel for business or pleasure.

The "advertising mileage," as editors called it, usually came in the form of one-thousand-mile books, which were good on one railroad line. Since most trips involved changing from one rail line to another, agreements with several railways were necessary. Warren did not hesitate to try to broker a deal with more latitude.

"You ask for mileage book over all parts of the Erie System," a manager of the Chicago & Erie Railroad Company in Chicago wrote to Harding, barely disguising his irritation. "Have to advise that, such a thing is not possible. We do not have one book which covers the entire system."[146]

Warren also made good use of tickets for passenger steamers, particularly favoring trips on Lake Erie or Lake Michigan to Mackinac Island, Detroit, Put-in-Bay and Canada:

Those were the good old days of rural journalism, when editors went on joint excursions and reuned with fellow publishers at meetings of editorial associations, meetings which Editor Harding rarely failed to attend. The memory of many an Ohio editor will revert with pleasure to a boat trip of country publishers up the Detroit and St. Clair rivers to Georgian Bay and the "Soo," a quarter of a century ago, which was taken on a chartered freight and passenger vessel along the Canadian shore, with Editor and Mrs. Harding among the congenial spirits of the party. At one point the boat stopped long enough for a picked "nine" of editors—Harding among them—to play a game of baseball with a team of local Canadian Indians. Those were days of newspaper individuality.[147]

As 1900 approached, the *Star* was a hot commodity, becoming known as one of the premier "inland" country newspapers in the nation. Feeling his newspaper's reputation had risen considerably, Harding raised the advertising rates to match those of much larger newspapers. While the national advertisers paid the new rates with merely a grumble, Marion businessmen were not happy. Even though Harding had given D.A. Frank, one of the owners of the Frank Brothers mercantile store on West Center Street, price breaks many times, Frank now complained about the rate increases in a private letter to Harding while the publisher was vacationing in Florida:

I am satisfied you are enjoying yourself in the sunny south and I hate to disturb you with business but I feel that it is necessary—for the welfare of the Star.

Now, Harding, we can't stand the rate. Of course you will say when you read this, "Then don't advertise," but if you do you will not mean it.

I go to New York to-night and upon my return I will look for a reply. If the rate is not satisfactory, it will be necessary for us to make other arrangements for advertising. I will tell you candidly that we do not want to make other arrangements but will do it as a last resort.[148]

After Harding replied that the rates were firm, Frank tried one more time to convince the editor to bend:

Friend Harding, I have your letter of 3/13—as a letter writer you are a success—but it won't win—no—nothing can persuade me to pay 15 cents an inch for advertising.

I give the Star *credit for being the best paper in this part of the state. You have made the rise of the* Star *prohibitory to us by charging 10 cents a line for locals and 15 an inch for display ads. I will try other styles of advertising and if I can't make it go to suit me, then I will do the prodical* [sic] *son act and come a running.*

Well, Harding, I am busy. I think you have killed the goods, etc.—but you know. Have a good time.[149]

In the end, Frank did play the "prodigal son act." He continued advertising in the *Star*.

The Call of Politics

Politics were a centerpiece of small-town life in Ohio, and Warren from an early age was privy to debates around the family dinner table in Blooming Grove and, later, in Caledonia. Warren often accompanied his father when Tryon made his doctoring rounds to neighboring farms and observed how people readily jumped into discussions and debates about community issues. Tryon was a Republican, as was the extended family of Hardings, so Warren followed in those footsteps.

The Hardings settled the little village of Blooming Grove in the northwest corner of Morrow County in 1820. From the time he could walk, Warren heard the stories of the family's near extinction in Pennsylvania during the Wyoming Valley Massacre. He listened intently to his elders tell of clearing the forested Ohio land, warding off wolves and worrying about feeding their families during the cold winters. His great-grandfather, George Tryon Harding, and his grandfather, Charles, as well as uncles and great-uncles, routinely passed around the leadership roles in Blooming Grove and North Bloomfield Township. Community service was part of the Harding family life.

Warren's grade school years, barely started in Blooming Grove and continuing in Caledonia, were typical of a rural education. He walked the few blocks from his Caledonia home on Main Street to the school building, did his schoolwork adequately and relished the free time away from his studies—no different than any of his young cohorts. Because of his father's profession, Warren's playmates sometimes called the younger Harding "Doc."

Residents in Caledonia talked about how Warren liked to memorize and then passionately recite speeches. "[Mr.] Kelly told of how Warren loved to speak pieces and frequently rendered Patrick Henry's 'Give Me Liberty or Give Me Death' on Friday afternoon, but his great aspiration was 'Horatio at the Bridge.'"[150] The narrative poem, written by Lord Macauley, described how underdog Horatius Cochles battled and beat the powerful king's army at a bridge in sixth-century Rome. Education in the 1800s centered on ancient legends and the classics, and Warren referred to them in his writings and speeches throughout his life.

Warren's higher education at Ohio Central College in the tiny village of Iberia, just seven miles from the farm outside Caledonia where his family had moved, would best be described as a high school academy. Yet despite its modest population, Iberia was a mecca of advanced education in that part of rural Ohio. Warren's impressionable years of fourteen to seventeen at Ohio Central allowed him to probe the views of philosophers, delve into religious discussions and learn about the importance of social issues. The school's leaders had been abolitionists, as had the Harding family, and that mantle of responsibility toward fellow men was instilled in the students as they moved toward the future, even while mindful of the hard, recent lessons of the Civil War.

When Warren arrived in Iberia in the fall of 1880, the fourteen-year-old eagerly joined impromptu student debates about the presidential election—James Garfield versus Winfield Scott Hancock. Finding himself outnumbered by young Democrats supporting Hancock, Warren valiantly pushed the Republican platform and a Garfield presidency. Garfield claimed the White House.

Thanks to his boyhood job setting type at the *Argus*, Warren already had an interest in newspapers. He became co-editor of the college's *Spectator*, which debuted in February 1882, when Warren was seventeen years old. Published every two weeks, the *Spectator* was printed in the shop of the *Union Register* in Iberia. The *Spectator* ended with Warren's graduation six issues later.[151]

Warren was pleased with the circulation. "The *Spectator*," Harding noted editorially, "is taken by every family in our city excepting a few stingy old grumblers who take no more interest in home enterprise than a mule takes in a hive of bees."[152]

Warren's stints on the *Spectator* and, later, on the *Mirror* gave him a taste of his future. He realized that newspapering combined his two interests: writing and the power to affect change. Working for someone else, though, would

not do; he needed to run his own newspaper, where he could not lose his job if he wore a Blaine hat to work.

Ohio politics was rough and tumble. Even President Theodore Roosevelt often remarked that he never understood the intricacies of the political scene in the Buckeye State. Ohio politics was an ever-changing landscape, with party bosses fighting for control of the state Republicans, alliances formed and alliances broken in the blink of an eye.

When Harding entered the newspaper business, Ohio was at the beginning of a twenty-year run of Republican supremacy in state legislature and state leadership. Cleveland and Cincinnati were the power centers, with Mark Hanna operating the party in Cleveland and northern Ohio and George B. Cox becoming the "honest" power broker in Cincinnati, a city known at the time for its political corruption. Joseph Foraker, a former Cincinnati judge, Ohio governor and U.S. senator, added another side to the power struggle:[153]

> *Senator Hanna, Senator Foraker and Boss Cox divided the political fruits of Ohio. When their interests met, they welded their majorities in the legislatures and passed laws that would benefit their power in various cities. They often fought each other with more bitterness than they opposed the Democrats.*[154]

Just like any other newspaper, Warren infused politics into the *Star* through the editorial columns. His first major editorial, focusing on prohibition, appeared on August 28, 1885. Warren evidently felt strongly about the issue, since he indulged himself in a lengthy and exceedingly wordy dissertation. He pointed to laws in Maine and Iowa, which had outlawed liquor, as failures in curbing the problem. He held up Wisconsin as a role model, explaining that the state was on the right track with a change in the way it licensed alcohol sales, making alcohol more difficult to obtain but not a law-breaking infraction. The upshot, he said, was that individual morality, not laws, would determine the issue:

> *Restraint people will submit to. They do so in every relation, and there are very few who will not make every reasonable concession for the general good. But absolute interdiction that is felt to be destructive of personal liberty…always has and always will be resisted.*[155]

Thirty years later, he would echo many of those same thoughts in debates in the U.S. Congress about national Prohibition.

Within the first year, Harding also expounded on the Knights of Labor, which many viewed as a radical group. Several Knights had been seen chatting up factory workers in Marion. Instantly, the business community sounded the alarm. The Knights reached their peak of membership in the 1880s and then melted away. To many businessmen in Marion, as well as in other cities, the Knights represented potential economic havoc because they seemingly did not appreciate the business owners' investments.

"It is quite the thing just now to denounce all capitalists as the enemies of the laboring man, but suppose all men who give employment to labor should withdraw their capital and allow the workshops and factories to remain idle. Would it benefit labor? This is a question the Knights of Labor should carefully consider before they turn a willing ear to the complaints of the hot heads and the fellows who would not be satisfied if they had the earth," Harding wrote hotly.[156]

Star readers, too, received an earful about the dangers of unregulated immigration, which was prompted by a general fear of communism in the country:

> *Our country must begin to protect herself. We like to receive foreigners who come to this country to become loyal and respectable citizens but America must not be made an asylum for foreign thieves and cut throats who seek to sow the seeds of communism. Marching columns must carry but the flag of stars and stripes in American streets, not the bloody red flag of the frantic communist.*[157]

He acknowledged that immigration made America, but now foreign countries were shipping paupers and those bent on crime. "The safety of our social body demands that check be made, and the quicker and more effective the better. Proper restrictions can be made and it should be done."[158]

Warren's political star was rising by the mid-1890s. He was the recognized leader of the younger generation of businessmen in town, who liked to congregate in the *Star* office. "Among our friends were many of the best young men of Marion," Warwick said. "They liked to come to the old office, and we always knew that we had their sympathy and that they were ready with their influence to help us among the people of the town. They never deserted us."[159]

Warren and some of his friends started the Young Men's Republican Club. While some of the old guard in town welcomed Warren's emergence as a Republican leader, some certainly did not. At the same time that he

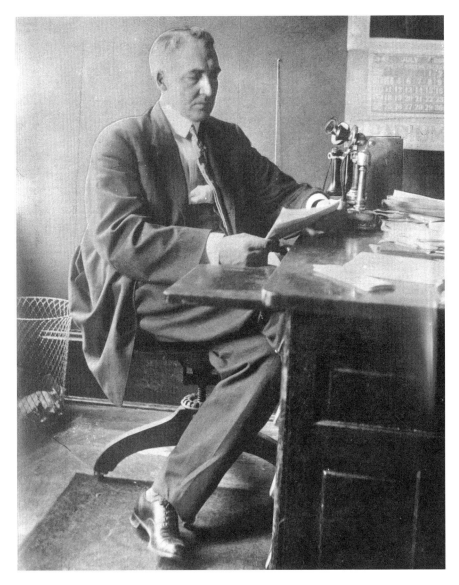

Publisher Harding at his desk in his *Marion Star* office in 1910. *Library of Congress.*

was edging forward in Republican circles, his newspaper had buried the *Independent* and had eclipsed the *Mirror*. The *Star* was now viewed as *the* newspaper in town. Signaling his stature, the committee planning a dinner to honor circuit court judge C.H. Norris in 1897 asked Warren to assume a prominent role: toasting "The Fourth Estate."[160]

As Harding's leadership role in the party grew, he found himself in a ticklish position in 1895. The Republicans did not have a solid candidate for Marion County auditor, and Democrat Upton Guthrie seemed a shoe-in. In the *Star*, Harding emphatically stated that the Republicans had the responsibility and duty to nominate a candidate, even if the candidate did not stand a chance. When no one came forward, Harding's Republican comrades pushed his name forward. In a case of "put your money where your mouth is," Warren accepted the nomination and lost the election but surprised the town by making a decent showing.

In 1896, Warren put the *Star* solidly behind Ohio governor William McKinley's run for the White House. The Ohio Republican Speakers Bureau recruited Warren to travel the state, making speeches for McKinley. He evolved into an eloquent speaker in the style of the day—slightly long-winded, spewing wordy sentences punctuated with passion. Warren drew audiences to him with his genuine warmth, good looks and conviction. He witnessed McKinley's front porch campaign in Canton, saw the crowds, heard the bands and believed in McKinley with everything he had.[161]

Meanwhile, the *Star* hummed along nicely and was at last generating healthy revenue. Warwick, as associate editor, kept the *Star* on track in the local news, while Van Fleet handled the advertising side. Harding's periodic absences from the office were not a particular hardship.

Warren liked politics, and he understood the mechanics of the party. On July 17, 1899, he was nominated for senator of the Thirteenth District, comprising Marion, Logan, Union and Hardin counties. His old pal William Cappeller of the *Mansfield News* could not help commending him—and poking some fun at his old chum.

"I am glad to know that you are on the list for the senate," he wrote.

> *I recognize that for a man to make the success out of a newspaper that you have of the* Star *must be neither modest nor particular. I can go as far in that line as you can and I will take it as a special favor if you will send your cut* [photograph] *and will be pleased to give it place in the* Ohio Newspaper Maker. *Now don't be finicky and say you haven't got a good one or the one you have your wife doesn't like and all that stuff. Send the cut and we will try it on the readers of the newspaper. If they can stand it, then I have every reason to believe your constituents will approve of your candidacy and make your election sure.*[162]

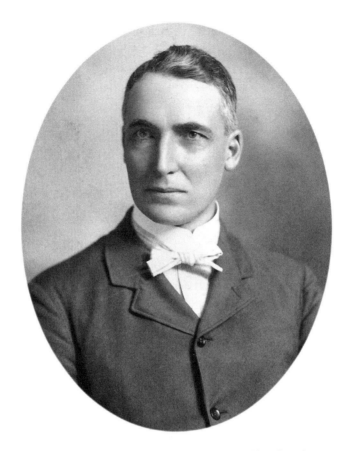

Ohio senator Warren G. Harding in 1900 at age thirty-five. *Courtesy of Ohio History Connection.*

Tryon, obviously proud of his son's nomination, put a campaign poster of Warren on his office door. Warren balked at the gesture, gently telling his father, "Let other people put up the pictures, father. They can all guess where you stand."[163]

Warren spent a pair of two-year terms in the Ohio Senate, which was in itself an accomplishment. Just once in the previous fifty years had the Thirteenth District retained its senator for two terms.[164]

Written during his second term, his senate biography noted Warren's modesty and "personal popularity." Listing the ten committees on which he sat, the biography also stated, "Senator Harding is one of the young men in the Ohio Senate. His earnestness in debate is equaled only by his frankness of statement."[165]

Warren became lifelong friends with senate clerk Frank Scobey. The pair traveled together with their wives on vacations over ensuing years, even after the Scobeys moved to Texas for Frank's health. Warren let his guard down with Scobey, writing him casual, breezy letters and expressing his inner thoughts. "He was soon regarded as a coming man in Ohio politics," said a newspaper reporter of Harding's senate days.

> *He was an excellent "mixer," he had the inestimable gift of never forgetting a man's face or his name, and there was always a genuine warmth in his handshake, a real geniality in his smile. He was a regular he-man, according to the* [standard] *of the old days—a great poker player, and not at all averse to putting a foot on a brass rail.*[166]

Warren's political star rose considerably during his Ohio Senate years. He was chosen to eulogize assassinated President McKinley in 1901 and was selected as floor leader of the senate. The key to his success was his ability to work with senators of both parties and to weave solutions to seeming impasses, which left each party saving face.

From 1904 to 1906, Warren served as lieutenant governor of Ohio, alongside Governor Myron Herrick. During this period, his hometown friends called him "Gov," a nickname he retained among his close friends for the rest of his life.

During these years, Warren was away from Marion and the *Star* a great deal, traveling back and forth to Columbus and accepting speaking engagements all over the state. In fact, a survey of this period in the Harding Presidential Papers reveals that he regularly received $40 to $50 (translating to more than $1,000 in 2013) for a speech and built a lucrative stream of income in addition to revenues earned at the *Star*. He tended to accept most of the speaking engagements extended by fellow publishers, such as the invitation from R.B. Brown of the *Zanesville (OH) Courier*. "I am gratified at your prompt acceptance and our people will be delighted to hear you," Brown wrote to Warren. "Your fame as a public speaker is abroad in this land and you are never disappointing."[167]

As he began his first term as lieutenant governor, the smooth-running *Star* hit an internal glitch. "It is my opinion that when Warren Harding left the *Star* to assume the Lieutenant Governorship he took the soul of the paper with him," Warwick wrote later. "I say that is my opinion, but I am willing to let the other boys in the old office have theirs."[168]

Those public words did not tell the whole story. Warren had elevated Van Fleet to managing editor, and Warwick remained associate editor.

Warwick, perhaps jealous of Van Fleet's new power and missing the way Harding wrote and managed, did not fully accept the new man in charge. After twenty years, Warwick left the *Star* for the *Toledo Blade*. For him, the fun was gone.

"For me, with the 'Big Dreamer' away for the greater part of a year, the office seemed deserted," Warwick said. "The flavor of the former days was gone. Even the ink seemed less pungent."[169]

In private letters to Warren, Warwick was more candid about his opinion of Van Fleet, yet he was homesick for the old place at the same time. In May 1904, shortly after joining the *Blade*, he wrote to Warren to offer his services—under certain conditions:

> The *Star* *seems to be in need of a soul, and whether I could supply it or not you are able to judge. I flatter myself that I have added a little to my knowledge of newspaper work since coming here.*
>
> *I do not wish to be understood as begging for a job, for, as far as I am concerned personally, I could not be more agreeably situated, and under no circumstances would I come to the* Star *in a position subordinate to that of the present so-called managing editor. I am not looking for trouble.*[170]

In the days before carbon copies of letters, Warren's answer is missing from the Presidential Papers. Yet Warren apparently bypassed the job offer with sensitivity, if Warwick's next letter to Warren is any indication:

> *Dear Harding, Yours of 26ᵗʰ received today, and I thank you for its cordiality. It was more like an old-time friendship letter than the discussion of a business proposition, for which I have a decided dislike. Had it in mind to write a long story in reply, but upon second thought was reminded that I am not of much account when it comes to a long story.*
>
> *I would be an ingrate not to wish the* Star *continued success, and if it would be in order, I would suggest that you take hold of the editorial column occasionally and put a little human nature into it. The paper and everybody connected with it—with a single mental reservation—have my heartiest wishes for success.*[171]

Although the prospect of working together again was dashed, the friendship endured to the point that Warwick, although hesitantly, felt secure enough to ask for a loan two years later:

Dear Friend: This is an April joke. I am going to presume on a friendship of longstanding to ask you for a little assistance. I am in a state of financial and consequently, mental distress, and am among people who seem like strangers when it comes to asking them for help of this kind. Would it be asking too much of you to let me have, in the event that it is not an inconvenience, a loan of $75.00 for six or eight months. I have some money saved, but it is where I cannot get to it for several months, and I have some obligations to meet at once. I came to you with the belief that you have some faith in my honesty and good intentions.[172]

The *Star* was soaring. With a large workforce and the necessity of additional presses, Warren worked with architect Frank Packard of Columbus to draw up plans for a new newspaper building. The *Star* had owned the old Baptist church across the street for many years, and Warren often talked of razing it and building a newspaper plant there.[173] He never acted on the plans.

The *Star* printing force, along with printers throughout Marion, unionized into the Marion Typographical Union in 1909. Warren wrote to the union organizer about his views on the matter:

If the boys want a union here and will unionize our leading job competitor and the Mirror, *there will be no opposition on the part of the* Star *management. I do not want to be put in the position of coercing any of the old employees into the union, but I have no objection to the boys organizing and making ours a union office.*[174]

As was typical of the relationship between Warren and his employees, the printers asked him to join his own union. He carried his union card in his wallet for the rest of his life.

The Other Woman

Phoebe Harding died in late May 1910 just as Warren prepared to launch his campaign for Ohio governor. The loss of the family's moral compass dragged Warren down physically and emotionally for months and was one he never fully reconciled. For the rest of his life, he kept his mother's photo on his desk and routinely placed fresh flowers in a vase nearby, just as he had brought her flowers in his youth.

His depression morphed into a lackluster gubernatorial campaign that fall. Although beating incumbent Judson Harmon would have been a long shot, his lack of enthusiasm and failure to energize the voters contributed greatly to his substantial loss.

Immediately following his defeat at the polls, Warren resolved to turn his back on politics and return to the editor's chair. He resumed his old routine in Marion—to a point. Two things had changed: first, his political accomplishments had made him a permanent fixture in the state's Republican leadership, and second, an outside love interest occupied many of his thoughts and had an impact on his actions. Warren Harding had a secret relationship with Marionite Carrie Phillips.

The Hardings had been good friends with Jim and Carrie Phillips since the 1890s, often attending social events and taking trips together. In 1905, the stars aligned for better or worse, permanently changing the lives of four people.

Warren, dealing with the strain of Florence's hospitalization following emergency kidney surgery in Columbus, and Carrie, trying to rebound after the death of her two-year-old son, became confidants. Soon, the good

Warren G. Harding in 1910 at age forty-five, the year he lost the Ohio gubernatorial election. After the election, he returned to his editor's chair full time at the *Marion Daily Star*—at least for a while. *Courtesy of Ohio History Connection.*

friends slipped into a flirtatious relationship and then discovered stronger feelings. The two kept each other at arm's length for three years before consummating their relationship. Carrie kept stacks of Warren's letters, which were discovered after her death in 1960, but Warren had destroyed the letters that she wrote to him.[175]

From those one-sided letters, there is little doubt that Warren truly loved Carrie. Although Carrie sometimes treated Warren as a prize to be won and often engaged in emotional blackmail, it seemed as if she loved him as well. Whatever her true feelings, she clearly possessed emotional power over him. Whether Jim Phillips and Florence Harding knew about the affair is open to

speculation. Common sense and Florence's frequent outbursts about Carrie over the years, though, point to the likelihood that she was well aware of the relationship. In addition, Florence's four-year list of Christmas gifts does not include Carrie's name after 1910, suggesting that might have been the pivotal year.[176]

Following his loss in the gubernatorial race, Warren wrote to family and close friends that he was done with politics. This, in part, was due to Carrie's insistence that he avoid public life.[177] The other part, most likely, was his embarrassment over the recent election results.

Warren wrote lengthy letters to Carrie, often detailing what was going on at the *Star*. On January 1, 1913, he wrote about the *Star*'s impressive financial year in 1912 and that he was starting a new weekly.[178]

The *Ohio Star* debuted in tremendous fashion. As the fifty thousand inaugural copies were coming off the press, a stripped gear of the press suddenly broke, shooting several of the gear teeth through the *Star*'s front plate-glass window. "One of those gear teeth would have killed or maimed if they had struck anyone," he wrote to Carrie.[179]

The weekly, although the result of a tremendous amount of work, did not last long. The collapse of the weekly did not seriously affect him, as he previously had told Carrie, "If it falls flat it will be no dream of mine shattered."[180]

Despite his earlier pledge to Carrie that he would not pursue another political office, he did not keep his promise. He entered the race for U.S. Senate in 1914. "I am in politics, up to my ears, with all its cares, worries, anxieties and heartaches, with all its excitements and compensations," he giddily wrote to her, noting that several typists were required in the *Star* office to keep up with campaign correspondence.[181] Carrie, not pleased, bluntly wrote to Warren that she was interested in another man, a tactic she used more than once.[182]

The relationship ran hot and cold over the next few years, and each delighted in fanning the emotions of the other by reminding the other of earlier romantic liaisons. Carrie and her daughter, Isabelle, moved to Germany and became enamored of the culture and politics as the world braced for war—a dangerous stance, indeed. Speculation exists that Carrie might even have been a low-level German spy.[183] By the time he was in the Senate, Warren seemed to realize that the love affair could go no further; he sometimes confessed to her his belief that no one man could satisfy her.

11
The National Stage

Warren won the U.S. Senate election in 1914, and the Hardings looked over a list of houses available for rent in Washington. They turned off the utilities and closed up their Marion house. They first rented a house and then renovated a stately brick home on Wyoming Avenue using Florence's recent inheritance from the death of her father the previous year—the first money she had received from Amos since leaving his house to marry Warren.

The first year in Washington was a trying one. Florence was recovering from another bout of kidney disease and was in bed or a wheelchair for all of 1915.[184] And the *Star* demanded Warren's near constant attention.

Nearly every day, letters crossed his desk from Van Fleet or Myers, asking Warren's advice about newsprint purchases and advertising problems or requesting that he settle a dispute among the managers. Warren urged Van Fleet to make decisions about the day-to-day *Star* operations on his own, but Van Fleet often seemed reluctant to close a matter without Warren's input. This was understandable. Van Fleet clearly felt an immense responsibility in keeping the highly visible Harding's livelihood alive and well. And Warren himself never shrugged off Van Fleet's questions and comments, suggesting that he did not really want to be a hands-off owner.

Concerned that some subscribers were dropping the *Star* rather than renewing, Warren instructed his staff to use the telephone to reach subscribers—a new twist in retaining customers. Birdie was not happy about the plan since most of the work fell in her lap. She wrote to the senator without the other managers' knowledge, saying the *Star* leadership was not

The *Marion Star* time clock, punched by the newspaper employees each day at the East Center Street office. *Harding Home Collections.*

behind the plan. "I did not know that there had been any question whatever about the practicality and desirability of applying the telephone method of securing renewed subscriptions," he replied, clearly surprised. "I have a very great confidence in the effectiveness of this plan when diligently worked out and I very much desire to see it thoroughly tried."[185]

From Washington, Warren changed the *Star*'s press time to 3:15 p.m., causing a mini rebellion in the *Star* office. His reasons were solid: an earlier press time would ensure that the paper would make the 4:00 p.m. Columbus, Delaware and Marion (CD&M) interurban for deliveries south of Marion. He also hoped the rowdy carrier boys could start their deliveries earlier in the afternoon, cutting down on the pushing, shoving and noise when they congregated on the *Star*'s second floor waiting for the press run to end. The earlier deadline required all of the departments, from the newsroom to the advertising staff to the composing room, to synchronize their altered schedules. Soon, the whole staff was buzzing with complaints and misinformation. Each of his managers wrote to him independently, complaining about the others. Van Fleet said the staff could not do it; Myers said the earlier press deadline could prevent some ads from going into that day's paper.

After reading his managers' differing accounts, Warren wrote a stern letter to Van Fleet, telling him to put a lid on the situation by addressing the whole force at one time in a straightforward manner. To Van Fleet's report that the tactic had worked, Warren wrote, "Very pleased to learn that there is no acknowledged friction among the members of the force. I did not think it would prove a very serious situation if the fellows were gotten together and the matters talked over in concert when each man was looking the balance of the force directly in the face."[186]

Still, he tended to soothe hurt feelings by assuming part of the responsibility himself. "It may be that my insistence on closing the forms at 3 to 3:10 o'clock surprised you and it may be that it is a real innovation for our office, nevertheless it remains my best judgment," he wrote to Van Fleet.[187]

When 1917 brought war to Europe and potential American involvement, citizens across the country were asked to contribute to the nation's war effort. Marion County was assigned a $750,000 quota in war bond sales. Newspapers, of course, were expected to get behind the national effort and urge thrift. Van Fleet took a direct hit from *Star* advertisers, who complained loudly about the newspaper's double standards. They argued that the *Star* editorials urged thrift in all but necessities, while Myers simultaneously prodded them to spend more to advertise "nonessential" goods. They had a point.

"The thrift and war certificate business has gotten my goat," Van Fleet complained in a letter to Warren in late 1917.

> *The day after we ran it* [a government article on thrift], *I went down to the* [Marion] *Club for luncheon and Charley Landon, Ben Blake and Dan Frank jumped on me about paying good money for advertising and then have the paper run this thrift stuff, which advised people to buy nothing they could possibly get along without, and spend everything they could possibly apply to the purpose for thrift stamps and war certificates.*[188]

Warren calmly replied that the nation's needs took precedence over Marion's needs.[189]

Just a month later, Warren found himself again distracted from his Washington business by sober news from Marion. Downtown Marion literally was springing leaks. The January thaw caused the paving on the streets to rise, snapping some of the hydrant pipes. One of the pipes broke at the corner of State and Center streets, sending a torrent of water into the *Star* press room. Van Fleet, in recounting the matter to Warren, said the water rose eighteen inches, nearly swamping the motor pits of the presses.[190]

With the flooding under control in the next two days, the temperature plummeted and, with it, the already curtailed natural gas and coal supplies allotted during wartime. The linotypes required a high temperature in which to melt the metal, so ingenuity was the key to the *Star*'s ability to keep its machinery running in order to publish. "We could get the metal hot enough to cast [type] but not sufficiently hot to go through the pipe without freezing it up and the only way we succeeded in getting to press Tuesday was in our holding a gasoline blow torch on the pipe," Van Fleet wrote.[191]

Following the Armistice in November 1918, businesses across the country faced a common problem: how to lower the high wartime wages to prewar levels without igniting rebellion among their employees. Many businessmen assumed that their employees would understand the wage reductions. They were wrong. In many cities, the situation sparked strikes, violence and massive layoffs.

The *Star* also felt the heat. Van Fleet wrote to Warren about the members of the Marion Typographical Union, the printers who worked for Marion's newspapers. He had heard rumblings that the printers were going to demand higher wages. Warren urged Van Fleet not to panic. "I do not think our scale is seriously out of way, when the bonus which you will pay this week is added," he wrote. "I do not think it necessary to make a horizontal increase throughout the office or, one above that already arranged."[192]

Warren, though, was reconciled to possible layoffs if discontent continued. "You strike the key to the real situation when you allude to the lay-off of various members of the force," he noted.

The problem of the high cost of living is really not the most serious thing in itself. The difficulty is that everybody wants to indulge in high living and there is a fever throughout the country for more wages in every class of employment, and to meet the request does not in any way help to correct the existing situation.[193]

At the same time, *Star* management readied itself for a potential telegraphers' strike, which would affect both the Hearst service and United Press. Warren instructed Van Fleet to drop Hearst and immediately switch to the Associated Press if a strike appeared imminent.[194]

Myers, as advertising manager, constantly haggled with Marion businessmen over the *Star*'s ad rates. In early 1920, Myers wrote to Warren about the unevenness of increased advertising rates. He said that rates had not been raised evenly across the board for all businesses in the past, so the businesses used to bargain rates now resented a hike. Myers was hesitant to raise the rates for a troublesome client, Hughes and Cleary menswear, and favored leaving the rates low so Cleary would not complain. "As you know, Cleary is a consistent booster of advertising, uses the *Star* exclusively, but enjoys kicking," Myers wrote. "It was my way of handling this situation and believe it will make us a lot more money and prestige than the loss of 4 cents per inch on three months of advertising."[195]

While not dictating Myers's course of action, Warren offered a word of warning. "I know it is a very delicate problem you have to work out and I am sorry there arise now and then differences of opinion as to what is best to do in a given cause," he wrote. "If you think it best to go on with the Hughes and Cleary contract [at the lower rates], I will consent to your doing so, but I venture to write the warning that it may come back to haunt you if the favored treatment of the firm ever becomes known among your advertisers."[196] Myers heard his boss; Mr. Cleary's ad rates went up.

Warren enjoyed his tenure in the U.S. Senate but looked forward to his visits back home. Writing to Scobey, he was frustrated that politics interrupted his "vacation" at his editor's desk, perhaps realizing that he would never fully be able to sink back into his former self:

On arriving at Marion I immediately undertook the editorial management of the paper for ten days in order to afford Mr. Van Fleet a short vacation. I

Senator Warren Harding reviews a fresh copy of the *Marion Daily Star* in 1920. *Courtesy of Ohio History Connection.*

> *found the work most delightful indeed, except I was incessantly disturbed by calls for speech-making which could not be ignored. They were all pleasant enough and really very satisfying in their results, though it interfered very annoyingly with my attempt to properly direct the newspaper forces for the period I had assumed to do so.*[197]

Despite the ups and downs of newspaper publishing, Warren could not complain. The paper was making money. The *Star* management corps was doing its job, and the stock ownership plan in the Harding Publishing Company worked well. The company owned half the *Star* building, and the newspaper paid rent to it. The other half was in Florence's name. By 1913, the first year of income tax in the United States, Warren stated that he had grossed $19,290 ($447,962 in 2013 money). Included in that was his $7,500 senate salary and nearly $11,000 in stock and investment dividends.[198]

Going into 1920, Warren scribbled down the salary increases for his managers and then put them into a formal letter. Van Fleet's salary rose from $270 to $325 per year ($3,738 in 2013); Myers, $230 to $260 ($2,990); circulation manager James Woods and Schaffner, $210 to $240 ($2,760); and Warren, no increase at $410 ($4,716).[199]

Marion Plays Host to America

Warren G. Harding, despite his initial reluctance, entered the race for president in 1920. He was content in the Senate and did not have aspirations to climb higher. For four years, though, close friends and colleagues had cajoled and pleaded with him to consider the presidency, telling him that the nation needed his leadership. Once in the race, Warren's competitive juices flowed, and he wanted to win the Republican nomination. Still, he was philosophical about the process, knowing that losing was a distinct possibility and would not be the end of his world.

"I think I ought to say that neither of us are taking the big politics too seriously not to be normal, or to be unhappy over the possible results," Florence wrote to George Christian Sr. in early 1920, trying out for the first time official stationery from the Washington campaign office.

> *W.G. is really a philosopher about political fortunes. He smiles over adverse criticism, thinks much of it deserved, feels a strange pity for many who are fooled by noisy pretense or caught by the "bunk" which is revealed in the intimacy of senatorial relations or near-at-hand sensations. I fear our hero worship is ruined for all time.*[200]

When Senator Warren Harding received the Republican nomination for president in June 1920, it was a dream come true for Marionites. A few days after Marion celebrated the good news, Warren announced that he wanted to do a front porch campaign resembling McKinley's of twenty years earlier.

He was anxious to show off his town to the country, and conducting the brunt of the campaign from home meant Florence would avoid the rigors of travel and, hopefully, preserve her health.

Immediately, the newly formed Marion Civic Association swung into action. It appointed committee after committee to organize the local end of the campaign, from feeding the large delegations to housing them in private residences when the hotels filled. The campaign machine could not have been successful without the people of Marion providing the wheels. In turn, the thousands of visitors, newspapermen and campaign workers brought smiles to the faces of Marion's businessmen.

Part of that local enthusiasm probably was due to the fact that someone—anyone—in the town was on the national stage. But the brunt of that support genuinely was for Warren Harding himself. He had long been such a vital part of the city's tapestry that it somehow seemed right to help him now.

Warren arrived home from Washington on July 5 to a town overflowing with excitement and pride. Throngs of his fellow citizens gathered in front of his house to await his words. From the top steps of his front porch, he tried to tell his neighbors and friends what they meant to him, acknowledging that his political success was absolutely linked to his success at the *Star*:

> *There can be no mistaken appraisal of our relationship. It is too extended, too intimate, too thoroughly stamped by community interest. You and I, all of us Marionites, have been boosting this Marion of ours for considerably more than thirty years, and have shared in varying degrees the achievements attending to its development. The thought of development and progress, a desire to find our place on the map of Ohio, inspired us, and there was common interest in spite of the seeming selfishness attending rewards. We were all boosters together, because it is an engaging pursuit.*
>
> *Any distinction which came to me in that connection was due to the accident of my occupation as a publisher, rather than any spirit peculiarly my own...*[201]

The campaign plans called for Warren to address crowds of people from the front porch of his home, which conveniently resembled a bandstand. That front porch, with its distinct rounded part on the east corner of the house, became a symbol for Warren's personality and his message: simple, inviting and solid. His "Return to Normalcy" campaign slogan promised a common-sense approach to returning the nation to balance after America's preoccupation with the Great War.[202]

A front porch crowd. More than 600,000 visitors heard Senator Harding speak from his porch during the three-month campaign in 1920. *Courtesy of Ohio History Connection.*

"The Front Porch was really the transmitter to the whole country of the views of the candidate, the press the amplifier," Kathleen Lawler explained.[203]

Just prior to the opening of the campaign, the Hardings' kitchen was quickly enlarged and several servants added to keep a steady stream of food prepared for the senator's tightly scheduled breakfast, lunch and dinner meetings in the dining room. Next door to the east, the home of George Christian Jr. was turned into local campaign headquarters. George had been Warren's personal secretary in the senate office, so he and his family had been living in Washington. He still owned his Mount Vernon Avenue house, so he rented it to the Republican Party for seventy-five dollars a month that summer. All day, and often into the night, noisily clicking typewriters, the buzz of hundreds of conversations, the shrill rings of telephones, the clacking of the telegraph keys and the occasional bursts of laughter floated out the open windows of the Christian home. Warren's campaign office was in George's former dining room, which had been emptied of its furniture and carpets and outfitted with nothing much more than a desk and chair.

Behind George's house, a small, white cottage was built as a workspace for the newspaper reporters. The reporters called the hastily assembled cottage the "shack," and it was outfitted with everything they needed: telegraph lines,

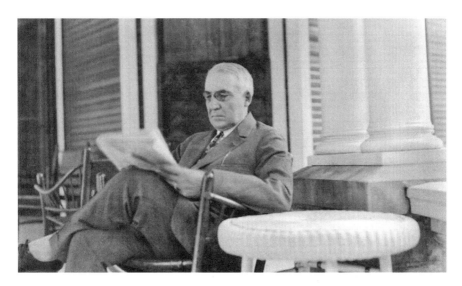

Senator Warren Harding relaxes on his front porch with a copy of the *Star* in 1920. *Courtesy of Ohio History Connection.*

telephones, typewriters and plenty of cigars and cigarettes. They ate the grapes from the arbors in the backyards of the Harding and Christian homes, picked apples from the Hardings' apple trees and generally made themselves at home.[204] They rented spare bedrooms in the houses of the neighborhood and ate breakfast in those same friendly kitchens, thus dropping extra dollars into the apron pockets of enterprising housewives. Among the newspapers represented were the *New York Sun & Herald*, *Washington Post*, *Pittsburgh Post-Gazette*, *New York World*, *New York Tribune*, *Chicago Tribune*, *Cleveland Plain Dealer*, *Philadelphia Ledger*, *New York Times* and, of course, *Marion Daily Star*.[205]

Warren's opponent, Governor James Cox of Ohio, owned the *Dayton Daily News* and *Springfield News*, so a matchup of Ohio newspaper owners was one for the record books. Both campaigns used newspaper reporters as major mouthpieces of their campaigns. No reporter in Marion did investigative work, just as no reporter in the Cox campaign peeked beneath the surface. The reporters in Marion represented Republican newspapers, and the reporters following the Cox campaign represented Democratic newspapers.

In those days, the candidate officially was "notified" of his nomination, an outdated tradition tied to the early days of America. Notification Day 1920 took place on July 22 in the Chautauqua pavilion in Garfield Park. Journalist Joe Mitchell Chapple rode to the park in one of the *Star*'s new Chevrolet delivery trucks.

The newspaper correspondents gathered around Warren and Florence Harding on the steps of the 1920 campaign press house in Marion organized the "Order of the Elephant." They invited Senator Harding into the group as their only honorary member. *Courtesy of Marion County Historical Society*.

"Are you sure the papers are all delivered?" Warren queried the *Star* staffers as he quickly strode to the vehicle upon their arrival. "If not, dump Joe and we will take care of him and see that he has some cherry pie."[206] On a day when he easily could have taken his eye off the *Star*, he remained the newspaperman. The *Star* sold thousands of extra papers that day, and Van Fleet told Warren that one person alone sent a check for 2,500 copies of the Notification Day coverage. Warren smiled at the news, thinking of the additional revenue for the *Star*, not his own fame.[207]

Warren and the reporters bonded quickly. Warren talked shop with them, and the reporters liked his easy manner. He held informal news conferences while lounging on the press house porch railing. At those times, he lit a cigar and announced he was ready for questions by saying, "Shoot!"[208]

The reporters working from the press house became a close-knit group and formed the "Order of the Elephant." They invited Warren to dinner in September, telling him about their group and accepting him as the only honorary member. They had pooled their money to buy him a specially inscribed cigarette case. Those same reporters, stationed in Marion in

President Harding made good on his promise to host the "Order of the Elephant" once he was in the White House. *Courtesy of Ohio History Connection.*

December to record any murmurings they heard about Warren's cabinet, were invited into the Hardings' dining room for a midday Christmas dinner on December 23.[209] Warren made good on his promise to host the "Order" at the White House shortly after the inauguration.[210]

In the practice of the day, both Harding and Cox had casual conversations with reporters and did not worry about those comments surfacing in print. If either misspoke, all either candidate had to do was to tell the reporters that those words were off the record, and the writers complied.

Warren wrote the bulk of his speeches himself after he and Republican leaders agreed on the "frame." As usual, he settled a pad of paper on a knee and drew a stub pencil from a pocket with which to write.

"The office man each morning arranged a row of new, sharpened lead pencils on Mr. Harding's table," Lawler said. "Mr. Harding would push them all aside, and turn his pockets inside out until he found stubs. If he needed a new pencil, he cut it in half and sharpened it himself."[211]

From the top step of his front porch, Warren gave speeches to ten thousand people or more twice a week, usually on Wednesdays and Saturdays. Gravel replaced the grass in the front yards of the Harding and Christian homes; manicuring a fine lawn that summer was out of the question.

"Although multitudes joyously journeyed to that shrine, and left enthused and happy, millions, of course, were unable to do so," Lawler said. "For each occasion, Senator Harding prepared a set address which was in the

office of every newspaper in the country, for release at the hour of delivery at Marion."[212]

Although based in Marion, Warren took several three- and four-day jaunts to thirteen states during the course of his three-month campaign. The reporters, newsreel men and photographers usually required a train car of their own. Along the way, some of the reporters "dropped off" after interviewing the candidate so they could find a telegraph office and send their stories to their newspapers.[213]

Election day, November 2, was Warren's fifty-fifth birthday. The Hardings' polling place was in a garage a couple of blocks away, which had been outfitted with strings of light bulbs so the newsreel cameramen could film. Florence became the first woman to be able to vote for her husband for president; the Nineteenth Amendment allowing women to vote was ratified in August of that year.

That night was unlike any other in Marion's history. Warren and Florence stayed up late—reportedly until 5:00 a.m.—greeting Marionites who flocked to the green house on Mount Vernon Avenue to issue personal

The gold printer's rule was a gift from *Star* employees on November 2, 1920, the day Warren Harding was elected president. Old-time printer Lew Miller handed the rule to Warren. Engraved on it are the words: "Best Wishes to Senator Warren Harding, 1865, Nov. 2, 1920, From *Star* Employees." *Harding Home Collections.*

congratulations after Warren had clinched the victory. All that night, downtown Marion was a noisy and lively place, especially around the *Star* office, as Warren's neighbors rang cowbells, showered one another with confetti and beat drums to celebrate.[214]

After Governor Cox conceded, a contingent of about fifty *Star* employees arrived at the Hardings' house. They presented Warren with a solid gold

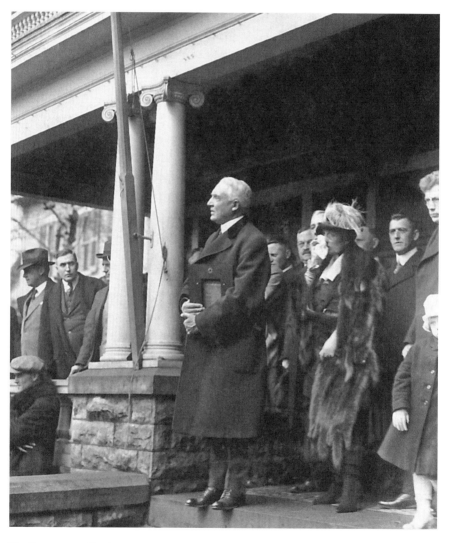

Harding says goodbye to his friends and neighbors as he and Florence prepare to leave Marion for the March 4, 1921 inauguration in Washington, D.C. *Courtesy of Ohio History Connection.*

thirteen-em makeup rule, inscribed with his birth year (1865) and election year (1920), as well as the "November 2" date of both his birthday and election day.

An obviously touched Warren Harding addressed this special group: "You and I have been associated together for many years. I know you and you know me. I am about to be called to a position of great responsibility. I have been on the square with you and I want to be on the square with all the world.

"There is my old friend Miller, the oldest employee of the *Star*," he said, wiping tears from his eyes and pointing to the seventy-four-year-old printer. "Thirty-six years we have been together and sometimes those years have been thorny. Sometimes Miller has drawn his pay that I had to borrow from my own mother. Sometimes, the next morning, I have had to borrow back from Miller the pay he drew the day before."[215]

The Hardings' goodbyes to Marion two days before the March 4 inauguration were tearful as Warren clutched the plaque with which he had been presented. "I like to think that in the greater part of my life in this community I have done some things which have merited your approval; and I can wish for nothing better than that I may come back to you at the end of my public service with an esteem from our common country measurable to that which you have shown me here at home," he told the crowd gathered for the last time in front of his porch.[216]

Warren saw America as a collection of thousands of communities just like Marion. That belief was at the heart of how he would govern the nation in the next two years—neighbors serving neighbors, goodwill the desired outcome of every decision:

> *I have a theory of government that if you do for the nation what you do for the community you do exceedingly well; because the nation is only the aggregate of communities. So I am going to play my part in the execution of my duties as chief magistrate of the republic just as I would play it as a neighbor and fellow citizen in Marion.*[217]

13
Editor in Chief

O n March 4, 1921, Warren Harding strode into the White House as the first member of the Fourth Estate to become president. He faced an enormous slate of problems when he sat down at his desk in the executive office at seven o'clock the next morning. The economy was out of balance due to the enormous expenses of wartime; 1918's armistice with the Central Powers had to be cemented with peace treaties; thousands of disabled soldiers strained the hospital services in the nation's capital; and, just as important, Americans needed to learn that their country was headed in the right direction.

Just as he always had done, Warren reserved the early mornings for writing. At first, he tried to answer each piece of correspondence with a personal, handwritten note. The practice may have worked in Marion, or in both of his Senate positions, but certainly did not in the White House. Warren simply could not physically answer the hundreds of letters arriving daily from Americans all over the country. He soon turned over much of the duty to Secretary George Christian Jr.'s staff.

Lawler, who had joined the White House staff as Mrs. Harding's assistant, said trying to give his nationwide constituents the same personal attention he had given to his state or local constituents "drained President Harding. He never eased himself; he never spared himself. When he could call a stenographer instantly by pushing a button, he chose to write out his thoughts and ideas with his pencil."[218]

Relinquishing control of his correspondence went only so far. Letters from children usually triggered a presidential response, as Betsy Clark

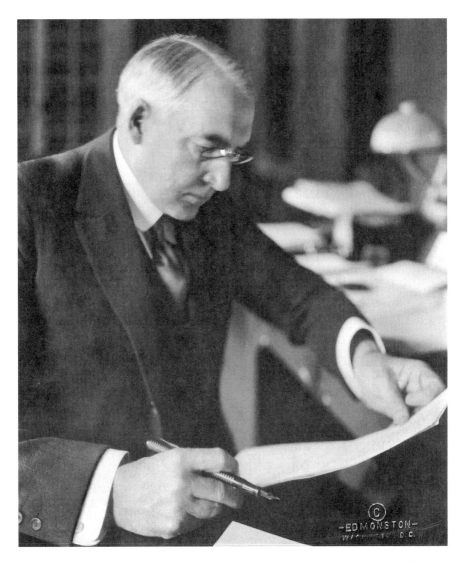

President Harding working at his desk in the Executive Office in the White House. *Courtesy of Ohio History Connection.*

and Katharine Jones from East Sixty-sixth Street in New York learned in December 1922. They wrote:

> *Dear Mr. President,*
> *We have seen your doggy's picture in the newspaper. We think he is awfully nice. Eleanor Kingsbury was at our school and she showed us the picture of*

you which you had sent her. At school we had an election for president. You had much more than Mr. Cox.

It must be fun living in that great big white house! Don't you think it's nice Christmas is so near! We do. We are both going to get dolls from Santa! At least if we are good.

We hope you and your Airedail [sic] doggy have a merry Christmas![219]

Warren responded in kind:

Dear Betsy and Katharine:
Thank you very much for your note. I wish you could both see Laddie Boy in real life instead of in the newspapers. He is just as good a dog lying in front of me in my study in the evening as he is in the newspapers.

I hope both of you will have a very happy Christmas and that meantime you will be so persistently good that you will get the dolls you want Santa Claus to bring you.

Your friend,
President Warren G. Harding[220]

Warren continued his good relationship with the press, just as he had during his Marion campaign. He had news conferences each Tuesday and Friday following cabinet meetings. "The President gave out news succinctly and frankly—he knew what was news."[221] Florence, too, broke ground by giving regular press conferences and interviews to female journalists.[222]

Even though he was removed from his hometown by distance and workload, Warren usually carved out a few minutes to spend with the *Star*, which arrived in the White House mail a couple of days after publication. The president took great pleasure in his success at having taught Laddie Boy to trot to his study with the paper clenched in his soft mouth. Warren loved to sink back into his chair and briefly immerse himself in his hometown. During these times, his thoughts wandered to the simpler days—when he strolled from his office to the Marion Commercial Club for lunch, shared a cigar with Van Fleet after the paper had been put to bed and joined in the laughter when the printers played a joke on old Lew. He knew that, even when he left the White House and could write again for the *Star*, nothing would be quite the same.

A newspaper writer, in the days prior to the inauguration, described the president as someone who "walked slowly, talked slowly and made up his mind slowly." To present-day historians, that description has been

The "editor's chair" was a gift from newspaper editors across the nation who were thrilled that one of their own was in the White House. Editors each pitched in one dollar to go toward the gift, which was presented to President Harding in July 1921. The chair was placed in the president's private study, where it became a favorite perch for his dog, Laddie Boy. *Courtesy of Ohio History Connection.*

interpreted to mean he was a bit slow-witted. To those who knew Warren, that description would only make them smile. Warren was not one to rush anywhere—some might say he ambled—so yes, he did walk slowly. And although he prided himself on his speech-making ability and liked to shoot the breeze with people, he really was more of a listener than a talker. He did indeed make up his mind slowly—just like any good newspaperman would do in weighing all sides of an issue.

Warren Harding the president used much of the same reasoning to address issues as had Warren Harding the small-town publisher. The ups and downs of building the *Star* were rooted in him so deeply that he could not do otherwise.

When President Harding and Secretary of State Charles Evans Hughes put into motion the Washington Disarmament Conference, for example,

Warren had two very different approaches from which to choose. One was to put himself at the forefront of the conference so he would get the credit for the results. The other was to take himself out of the equation and let the conference unfold without the appearance of political influence. He chose the latter.

The day after he dedicated the Tomb of the Unknown Soldier in Arlington National Cemetery, the president opened the conference with simple, brief remarks. He then turned the monumental event over to Hughes. The disarmament conference was an attempt to avoid further conflicts already swirling around the weakened European nations by limiting the numbers of battleships each nation could build. The battleship was 1921's version of a weapon of mass destruction. The president knew when to take the back seat, just as he had when he put Van Fleet in charge of the *Star* and told his staffers not to play his political accomplishments prominently in his own paper.

William Allen White, editor of the *Emporia Gazette* and not a particular fan of Harding, reluctantly gave the president the credit for the conference's success: "The passage of these treaties is due largely to the good sense and tact of President Harding…Mr. Harding is not an intellectual giant. He may not be a moral heavyweight. That is as it may be. But he is a courteous, sensible American gentleman, and he does bring home the bacon."[223]

Likewise, Warren followed his instincts when he pardoned socialist Eugene Debs in December 1921. Debs was in his third year of incarceration for antiwar activity under Wilson's Sedition Law. Warren knew he wanted to release Debs before he even took office but held off until the official peace treaties with the Central Powers were signed. Even when the treaties were all in place by November, most of the cabinet and even Mrs. Harding were opposed to the release.[224]

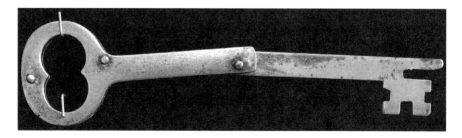

Warren Harding carried this skeleton key, which folded to fit in his pocket, for thirty-five years—including while he was president. It unlocked the front door of the *Marion Daily Star* and was a constant reminder of home. *Harding Home Collections*.

Daugherty wanted the release to take effect on December 31, but Warren changed the date to the twenty-fourth, saying, "I want him to eat his Christmas dinner with his wife." After he walked out of the prison gates, Debs satisfied Warren's request that he stop by the White House en route to his home in Terre Haute, Indiana.[225]

Writing to friend Malcolm Jennings about the Debs release, Warren said, "I was persuaded in my own mind that it was the right thing to do…I thought the spirit of clemency was quite in harmony with the things we were trying to do here in Washington."[226]

President Harding also freed twenty-three other political prisoners that day, and still others would follow:

> *A firm believer in judging each case on its merits rather than granting a general amnesty, Harding attempted to free every prisoner who was eligible. In each instance, his sole criterion was whether the person had committed any criminal or destructive act in connection with his antiwar activities.*[227]

The man who had fretted over news stories about sick youngsters and premature deaths in his hometown now opened his arms to the nation. He traveled to the Hoboken Pier in New Jersey on a heartbreaking mission: to meet a ship carrying more than five thousand war dead from Europe:

> *When the boat docked at the pier, the president gazed down the vista of a gloomy shed. There, draped in the Stars and Stripes for which they had so nobly fought and died, lay the bodies of six thousand of these same gallant young fellows. The eyes of Warren Harding, the man, filled with tears.*[228]

Harding's voice grew deep and husky as he fought back his emotions during his tribute to those soldiers, punctuating his hatred of war with a fist: "It must not be again! It must not be again! It shall not be again!"[229] When he ended the short speech with an impromptu rendering of "The Lord's Prayer," most of the quiet audience wept with emotion.

Warren felt a special connection with the young men who had come back from the trenches of Europe missing arms or legs or blinded by the mustard gas. One of his first acts as president was to authorize the creation of the Veterans Bureau to provide for the building of veterans hospitals, medical services and job retraining.

He had grown up revering the soldiers of the Civil War, and he now embraced those who had served the country in a new war. For all of his

admiration of the soldiers, however, he vetoed the popular Veterans Bonus Bill because the federal budget could not support it. He considered the federal budget books just a larger version of the financial books at the *Star*. One could not build a newspaper—or a country—without dollars in the cash drawer.

Warren's tried-and-true tactics to bring opponents to common ground also did not always work. He had demonstrated that unique ability time and time again over the years, from diffusing feuds among his newspaper managers to cooling tempers among Senate colleagues. During the summer of 1922, his talent was tested to the max. The nation faced tandem strike situations, one in the coal industry and one involving about a million rail workers. If left unchecked, either situation would cripple the nation. He felt strongly that neither industry had the right to put the entire nation at risk, a belief—again—that the good of the common country was more important than that of individual factions.

Away from the public eye, Warren called together several cabinet members, union workers and mine operators to smooth differences over wage scales and mine safety. He tried the same approach with the rail faction. Neither responded to his soft approach as conciliator, which disappointed and surprised him. The president approached Congress to intervene, but that body refused to get involved. Finally, Attorney General Daugherty sought an injunction—with Harding's full approval. The gutsy move prohibited rail workers from interfering with railroad operations. Historian Robert K. Murray called the broad ruling "the most sweeping injunction in American labor history."[230] Following the ruling, both the rail and coal situations diffused without the government resorting to the takeover of either industry.

One of the most pivotal events in Warren's presidency was a speech he gave in Birmingham, Alabama, in October 1921. Perhaps influenced in the back of his mind by the African American congregation that had been harassed so many years before in its Marion church, Warren told an audience separated by color on opposite sides of a chain-link fence that the race inequality in the South affected all Americans. Therefore, it would be treated as a national issue, not dealt with as a particular region saw fit. The remarkable speech marked the first time that a president had raised the race issue since Reconstruction following the Civil War.

"Let the black man vote when he is fit to vote; prohibit the white man voting when he is unfit to vote," he told a shocked audience. Admitting that the two races were different, he said economic, political and educational opportunities should be equally available to both.[231]

The speech, which was common sense in Warren's estimation, sparked extreme criticism among southern white factions who thought the president should have minded his own business. Black Americans were divided; some applauded his words, while others thought he should have pushed the issue further.

Once in awhile, Warren's instincts collided head-on with presidential duty. In early 1923, Daugherty and two senators warned the president that Veterans Bureau director Charles Forbes was lining his pockets with money gained by selling off government surplus medical supplies at rock-bottom prices and steering hospital building contracts to favored vendors.[232]

Warren called Forbes to the White House for an explanation and, shaking with rage, demanded his resignation.[233] The president, in keeping with his personal beliefs to allow a person to keep his dignity, permitted Forbes to leave the country before posting his resignation. He did not call for an immediate congressional investigation. Historian Murray said old-time political thinking also was at work. "Reverting to local Ohio political practice, he swept the situation under the rug."[234] The Senate ordered the investigation, without encouragement from the White House. President Harding had committed a colossal mistake that would cast a shadow over his own character.

Warren Harding grew into the presidency, just as he had grown into a mature newspaper publisher. He was sure of himself on controversial issues. He also was sure about the future of the *Star*.

On June 20, 1923, the *Star* carried the news of the start of President Harding's ambitious, fifteen-thousand-mile trip to the western states, Canada, Alaska, the Panama Canal and Puerto Rico. He called the trip the "Voyage of Understanding," and he meant to speak candidly to Americans along the way about the government's performance. At the same time, he wanted feedback from ordinary citizens about their daily experiences and how Washington could help them.

On the same day, a notice boxed in black on page one proclaimed some startling news: "President Harding Disposes of Control in the *Star*."[235] The *Star*'s printers, reporters and compositors naturally were worried that they would lose their jobs and that the *Star* would abandon Marion. They need not have been concerned.

Warren carefully selected the next owners of the *Star*. He was adamant that the *Star* remain Republican in tone, and he wanted owners who believed in the same standards of newspapering that he did. He had known Roy Moore and Louis Brush for years. He trusted them to treat his newspaper and staff kindly.

The sale of the *Star* was set at $550,000, a combination of cash and stock, which some later criticized as being an exorbitant amount of money for a newspaper with a circulation of 11,063. But the *Star* had made $60,000 in 1922 (more than $820,000 in 2013), and the value of a newspaper generally was based on the yearly profits as 10 percent of the worth.[236] Warren, who would stay on as a stockholder, would retire from active ownership but continue to write editorials after his presidency.

As his presidential train car, the Superb, swayed in a steady rhythm as it headed west, Warren seemed to embrace his newfound freedom out of Washington. His conviction grew as he spoke on myriad subjects, his words concisely framing his thoughts. He talked of the need to infuse basic civility—the Golden Rule—into Americans' everyday lives and in how nations dealt with one another. He boldly pushed for the United States to join the World Court to diffuse future conflict, an unpopular stance among most Americans. He spoke easily with people he met along the way, venturing into a Kansas wheat field to talk one on one with a farmer, shaking hands with factory workers and joking good-naturedly with boys and girls.[237] He reverted comfortably to country editor mode, asking questions, mulling over the facts he collected and enjoying friendly conversations. He was confident, clear-minded and totally himself.

His thoughts, too, returned to what he knew best: newspapering:

> *Having spent all of my life from very young manhood to my entrance into the Senate as a newspaper owner, I feel a great pride in the part I have had as a newspaper publisher. I am only the publisher of an interior daily paper, sometimes called a country paper. But if I had my life to live over, with all the experiences which have come to me, I would not change my profession or my occupation, nor would I alter the policy which has characterized the publication with which I have so long been associated.*[238]

14
-30-

The western trip ended in tragedy. When the entourage returned to the Continental United States from Alaska in late July, the president was ill. In fact, he had not felt well since a bout of influenza in January. In truth, the influenza probably masked a mild heart attack.[239] Even a vacation in Florida in March had not seemed to provide respite from insomnia, indigestion, a feeling of heaviness in the chest and immense fatigue.

Dr. Charles Sawyer, the president's Marion physician, publicly stated in Seattle that the president had been stricken with food poisoning. The situation, though, was more serious. Dr. Sawyer knew of Warren's heart problems, as did Warren's father, but probably did not want to believe—or just did not recognize—that a serious situation was unfolding. Dr. Joel Boone, Harding's naval physician, diagnosed an enlarged heart, rapid respiration and diminished heart activity.[240]

The decision was made to cancel all other West Coast speeches and go directly to San Francisco, where Stanford University cardiologist Ray Lyman Wilbur would meet the train. Warren was put to bed in the presidential suite of the Palace Hotel.

The next few days were tense. President Harding was gravely ill; his doctors and wife rarely left his side. On the morning of August 2, the doctors breathed a bit easier. Warren was cheerful, breathing more freely, had a restful night's sleep and was hungry. He told his sister Charity Remsberg, who lived in Santa Ana, that he was "out of the woods." His father in Marion, ready to board a westbound train at a moment's notice, cancelled

those plans when Warren's doctors gave him the welcome news that his son was on the road to recovery.

That night, at 7:30 p.m. Pacific Standard Time, Warren Harding peacefully died, much to the shock of the doctors, family and the nation, which had closely monitored the situation in newspapers across the country. His death, attributed to apoplexy (stroke) at the time, now is certain to have been a heart attack. With a modern eye to Warren's health, it is apparent that he suffered from congestive heart failure and had been plagued with heart problems for years.[241]

News of Warren's death reached the *Star* newsroom an hour later, at about 11:30 p.m. Eastern Standard Time that night, and a stunned Van Fleet rushed to Dr. Harding's East Center Street home to deliver the news before the older man heard about it elsewhere or puzzled about the mournful chiming of all the town's church bells. He contacted the president's brother, Deacon, who had already heard the news from a neighbor whose home was equipped with a radio.[242] Deacon hurriedly boarded a northbound train in Worthington.

Van Fleet, hardly able to absorb the horrible news himself, took on the job of telling a father that his son had died and watching the old gentleman's face contort in agony. Nearly weighed down by his raw emotions, Van Fleet did what he had to do: he returned to the *Star* office and began to make up a special edition of Warren's newspaper.

The next few days had to be surreal for Van Fleet. The constant *clickety-clack* of the telegraph bringing reports from the Harding train, which was crawling through cities and villages on its way east; the mourning cloth in purple and black decorating portraits of the president in nearly every Marion store window; and the hushed bustle of Marionites as they once again planned lodging and food for thousands of people expected to flood to the town, just as they had done during the joyous days of 1920. And the *Star* staff, feeling lost and deserted by the man who was the lifeblood of the newspaper, quietly went on with their duties—just as W.G. would have wanted.

Mrs. Harding understood the bond and loyalty between her husband and his employees. In the funeral procession, she gave the *Star* employees the spot of honor walking directly behind the hearse. Mrs. Harding also made sure that the procession passed the *Star* office building, which was solemnly dressed in black-and-white draped cloth.

The Harding Newsboys Association, which had officially formed during the campaign and included men long grown past the rambunctious days of their youth, issued a resolution:

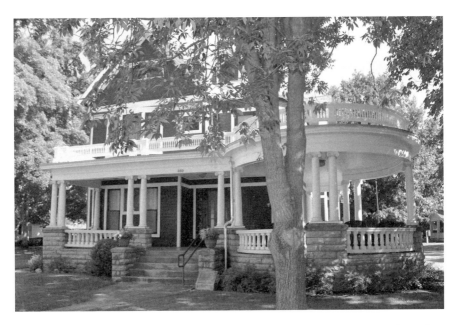

The Harding Home today. The front porch remains a focal point for visitors. The home has been open as a museum since 1926 and is 95 percent original. *Courtesy of the Harding Home.*

While recognizing that the late president of the United States belonged to America, and that his untimely removal is an immense calamity to the entire world, we feel that we have suffered a personal loss which others can not share. Our association is composed wholly of those hand-picked boys whom Mr. and Mrs. Harding—their fellow workers in the newspaper game—adopted and trained to do their special work as carriers of the Star. *Many of us owe our success in life to that first training and to the wonderful influence of our foster parents in business.*[243]

Van Fleet's initial editorial about his close friend and mentor appeared on August 3, the day after Warren's death. Most likely, Van Fleet had stayed at the *Star* office all night to write it. In part, it stated:

President Harding is dead.
This brief message, flashed around the globe, brought sorrow to the nation and touched the tenderest sympathies of the liberty-loving people of every land. But here in Marion, where we knew and loved him as Harding, the man; Harding, the fellow-citizen; Harding, the neighbor,

and Harding, the friend—rather than Harding, the president—the blackest grief obtains.[244]

Van Fleet's thoughts certainly turned to the man he had worked "with" for twenty-eight years, remembering his cluttered desk, his gentle leadership and—most of all—his belief that the *Star* would continue to shine. Van Fleet quickly typed "-30-" at the bottom of the page, the universal newspaperman's mark that the story had ended, ripped it from the typewriter and glanced at the clock. Time to put the newspaper to bed.

Epilogue

After President Harding's death in August 1923, the sale of the *Star* was completed, with Louis Brush of Alliance, Ohio; Roy Moore of McArthur, Ohio; and William Vodrey of East Liverpool, Ohio, purchasing the paper for $550,000, which included cash and stock. Later in the 1920s, Brush-Moore Newspapers was founded, and it purchased such papers as the *Canton (OH) Repository*, the *Portsmouth (OH) Times* and the *Salisbury (MD) Times*.

The *Star* moved its operation from Warren's East Center Street building to new quarters at 139–42 North State Street—just a three-minute walk away—in May 1925.[245] During the next four decades, it reported the ups and downs of the community and the nation, weaving its stories of garden club meetings, weddings and business comings and goings against a backdrop of three wars, seven presidents, civil rights battles, assassinations and violent student demonstrations.

In August 1967, Brush-Moore sold its ten newspapers to Thomson Newspapers for $72 million, the largest newspaper transaction in history. Included in the sale were the *Star*, the *Canton Repository*, the *Eureka (CA) Times-Standard*, the *Salisbury (MD) Times*, the *Hanover (PA) Evening Star* and the *Weirton (WV) Daily Times*. They were added to Thomson's other newspaper holdings in the United States (twenty-three), Canada (twenty-six) and Great Britain (twelve, including the *London Times*). The sale made Thomson the largest newspaper chain in the United States.[246]

Thomson purchased two buildings just north of the *Star* building on State Street, one of them the former Ackerman Hotel, and leveled them for a

parking lot. The entrance of the recently refurbished building now faced south on the tiny, narrow Court Street. One of the main reasons for that change was the construction of a vehicle overpass on State Street.[247]

In February 1995, the *Star* dismantled its presses and made arrangements to have the newspaper printed in Mansfield. Five years later, the *Star* was sold to the Gannett Corporation. In 2013, the *Star* picked up its operation again, for just the fifth time in its history, and moved to the southeast corner of East Center and State streets, ironically just a few steps west of where Warren's beloved *Star* building had stood. In 2014, the *Star*'s press operations were picked up by the *Columbus Dispatch* printing plant.

Some of the key people Warren worked "with" at the *Star* remained with the newspaper for many years after W.G.'s death.

BIRDIE HUDSON, who hired on at the *Star* as a stenographer in 1907 and served as a bookkeeper and general secretary, was employed by the newspaper until about 1924. During most of her life, she lived with her parents on North Main Street. She married William L. Vermillion, a steamfitter, in 1925. The marriage lasted just a year and a half, however. Birdie died of myocarditis following a gall bladder operation on January 24, 1927. She was just forty-four years old.[248]

ARTHUR J. MYERS, advertising manager, died of an apparent heart attack in his sleep in 1921 at the age of forty-five, shocking the *Star* staff and a newly inaugurated President Harding. A.J. had grown up at the *Star*, serving as a carrier boy when he lived with his family on North State Street. After his marriage, he and his wife, Gertrude, lived on Summit Street and then moved to Girard Avenue. The Myerses had two daughters, Dorothy and Jane. The girls were just eleven and three when their father died.[249]

FRANK "JACK" WARWICK, associate editor, chipped in to help purchase the *Star* in 1884. In 1904, he took a job at the *Toledo Blade*. He married the former Edith Parsons in 1890, and they had three children, Howard, Walter and Edith. While in Marion, the Warwicks lived first on West Church Street and then on Summit Street. Jack was the consummate newspaperman and clearly loved what he did; he worked at the *Blade* until he was eighty-four years old. He died two years later in 1947 and is buried at Toledo Memorial Park.[250]

WILLIAM "BILLY" BULL spent thirty-six of his thirty-eight years at the *Star* as composing room foreman. Born on August 27, 1866, in Battle Creek, Michigan, Billy arrived in Marion when he was eleven years old. He attended school in Marion through the eighth grade and went to work. Billy was the twenty-year-old manager of the Eating House, a restaurant near the railroad tracks on West Center Street. Warren ate there once in awhile,

and the two struck up conversations. Billy joined the *Star* as a printer's devil in 1886, earning $1.50 per week. He married Green Camp resident Ada LeFever in 1891, and the two resided on South High Street. Their son, Warren, possibly was named after the *Star* editor. Billy worked at the *Star* and then left to go into real estate. He died on February 13, 1953, at the age of eighty-six.[251]

MARTIN "LEW" MILLER, often fondly referred to by Warren as the oldest member of the *Star* staff, worked in the printing business for sixty-nine years and outlived Warren. When he died on March 27, 1932, at the age of eighty-two, he was believed to have been a printer longer than anyone else in central Ohio or even the entire state. The elderly Lew, sporting a goatee and drooping moustache, died just three years after retiring from the *Star*. Even in retirement, he walked to the *Star* several times a week from his North Main Street residence, where he boarded, just to pass the time in the old office.[252]

GEORGE VAN FLEET, just a year older than Warren, hired on at the *Star* in 1895 as the telegraph editor and city editor. A graduate of Ohio Wesleyan University, George worked his way through the ranks at the *Star*, eventually being named managing editor, mainly to run the newspaper when Warren was away from the office. One of Warren's closest friends, he became the editor and publisher after Warren's death. In 1899, at the age of thirty-five, he married the former Carrie P. Wallace, who was just twenty-three. They lived in the same East Church Street home where George had grown up, along with George's widowed mother, Elnora.

George retired from the *Star* in 1932, when his health began to fail, and he died of an apparent heart attack in 1935 at age seventy-one. In his obituary, the *Star* paid tribute to the man who was responsible for giving W.G. the peace of mind that the newspaper would be operated to his standards while he served as senator, lieutenant governor, U.S. senator and president. George was a "man of driving energy, tireless and devoted to his work, with a capacity for sincere appreciation for a job well done, with little patience for those who shirked their duty, and a stickler for accuracy."[253]

Until the end of his life, George guarded W.G.'s reputation, which was battered in the years after the president's death. In May 1925, he commented editorially on the exaggerated and off-base stories about Warren that kept surfacing. Dr. Alexander Irving, who claimed to know the president well, had addressed the Columbus Chamber of Commerce, expounding on his theory that overconsumption of eggs had caused Warren's death.

Van Fleet had had enough. He wrote that Irving obviously did not know Warren well or he would have known that Warren did not like eggs. "It is

the old, old story. People like to shine by reflected greatness," George wrote. "[Harding] has gone now, and it appears to his real friends and those who were really closely associated with him that it is about time for a lot of the absolute rot uttered concerning him to cease."[254]

Notes

CHAPTER 1

1. Chapple, *Warren G. Harding*, 40.
2. Ibid., 42.
3. Ibid.
4. Warwick, "A Boyhood Dream Comes True," in *Growing Up with Harding*.
5. *Marion Daily Star*, June 15, 1895.
6. Cuneo, *From Printer to President*, 58.
7. Romine, *History of the Marion County Courthouse*, 6.
8. *Marion City Directory*, 1882.
9. Warwick, "Boyhood Dream Comes True."
10. Warwick, "The *Star* Acquires a Money Drawer," in *Growing Up with Harding*.
11. Warwick, "Boyhood Dream Comes True."
12. Chapple, *Warren G. Harding*, 45.

CHAPTER 2

13. *Marion Daily Star*, November 29, 1884.
14. Ibid.
15. Warwick, "Boyhood Dream Comes True."
16. Cuneo, *From Printer to President*, 24.

17. Dr. Richard Harding, chair, Neuropsychiatry and Behavioral Science, University of South Carolina Medical School, in presentation at a Warren G. Harding Society luncheon, Cincinnati, Ohio, November 2011.
18. Warwick, "Boyhood Dream Comes True."
19. Ibid.
20. *Marion Daily Star*, December 27, 1884.
21. Ibid., December 2, 1884.
22. Ibid., November 28, 1884.
23. Ibid., March 11, 1885.
24. Harding Presidential Papers, Box 24.
25. *Marion Weekly Star*, August 25, 1888.
26. Ibid., December 26, 1884.
27. Ibid., December 24, 1884.
28. Warwick, "*Star* Acquires a Money Drawer."

CHAPTER 3

29. Cuneo, *From Printer to President*, 76.
30. *Marion County History*, 1883.
31. *Marion Independent*, December 12, 1884.
32. Ibid., September 1885.
33. *Marion Daily Star*, December 15, 1885.
34. Ibid., February 16, 1885.
35. *Marion Independent*, March 24, 1885.
36. Ibid., June 30, 1885.
37. Ibid., July 3, 1885.
38. *Marion Daily Star*, June 16, 1885.
39. Ibid., July 3, 1885.
40. Ibid., February 23, 1886.
41. *Marion Independent*, October 9, 1885.
42. Ibid., May 20, 1887.
43. Francis Russell, *Shadow of Blooming Grove*, 74.
44. *Marion Daily Star*, May 21, 1887.
45. *Democratic Mirror*, May 26, 1887.

Chapter 4

46. Warwick, "*Star* Acquires a Money Drawer."
47. Warwick, "Teaming It to Make Both Ends Meet," in *Growing Up with Harding*.
48. *Marion Daily Star*, December 23, 1884.
49. Ibid., January 15, 1885.
50. Cuneo, *From Printer to President*, 81.
51. Chapple, *Warren G. Harding*, 45.
52. Warwick, "Looking Like Real Success," in *Growing Up with Harding*.
53. Warwick, "A Blowup and an Embarrassing Rip," in *Growing Up with Harding*.
54. *Marion Daily Star*, January 20, 1886.
55. Harding Presidential Papers, Box 2.
56. *Marion Daily Star*, July 1, 1885.
57. Chapple, *Warren G. Harding*, 45.
58. Russell, *Shadow of Blooming Grove*, 63.
59. Sullivan, *Our Times*, 92.
60. Warwick, "*Star* Acquires a Money Drawer."
61. *Marion Daily Star*, June 16, 1885.
62. Harding Presidential Papers, Box 2.
63. *Marion City Directory*, 1889.

Chapter 5

64. *Marion Daily Star*, January 9, 1885.
65. Ibid.
66. Warwick, "Teaming It to Make Both Ends Meet."
67. Ibid.
68. *Marion Daily Star*, April 29, 1887.
69. *Marion Weekly Star*, December 8, 1888.
70. Ibid., August 21, 1889.
71. Ibid., December 8, 1888.
72. *Marion Daily Star*, December 19, 1886.
73. Warwick, "Persuading Marion to Advertise," in *Growing Up with Harding*.
74. *Marion City Directory*, 1890–91.
75. *Marion Daily Star*, June 15, 1895.
76. Ibid.
77. Ibid.
78. Ibid.

79. Harding Presidential Papers, Box 46.
80. Ibid., Box 24.
81. Ibid.
82. Ibid.
83. Ibid.
84. Ibid.
85. Ibid.

CHAPTER 6

86. Russell, *Shadow of Blooming Grove*, 92.
87. Chapple, *Warren G. Harding*, 61.
88. Ibid.
89. *Marion Daily Star*, March 3, 1885.
90. Ibid., July 9, 1891.
91. Ibid., January 15, 1885.
92. Johnson, *Life of Warren Harding*, 50.
93. *Marion Weekly Star*, February 2, 1889.
94. *Marion Daily Star*, June 3, 1885.
95. Harding Presidential Papers, Box 45.
96. Ibid.
97. Ibid., Box 24.
98. Ibid.
99. Ibid.
100. Ibid., Box 1.
101. Ibid., Box 24.
102. Ibid., Box 61.
103. *Marion Daily Star*, July 9, 1895.
104. *Marion Weekly Star*, January 26, 1888.
105. *Marion Daily Star*, February 11, 1885.

CHAPTER 7

106. *Marion Daily Star*, January 13, 1885.
107. Ibid., February 6, 1885.
108. Ibid., March 12, 1885.
109. Ibid., December 3, 1884.

110. Ibid., July 18, 1885.

111. Warwick, "*Star* Acquires a Money Drawer."

112. *Marion Daily Star*, June 29, 1885.

113. Ibid., February 8, 1885.

114. Ibid., December 4, 1885.

115. Harding Presidential Papers, Box 2.

116. *Marion Daily Star*, March 11, 1913.

117. Ibid., February 4, 1886.

118. *Marion Weekly Star*, February 11, 1888.

119. Dean, *Warren G. Harding*, 73.

120. Murray, *The Harding Era*, 122.

CHAPTER 8

121. *Marion Daily Star*, February 15, 1953.

122. Cuneo, *From Printer to President*, 14.

123. Anthony, *Florence Harding*, 24.

124. Harding Home "Fireside Chat" program, January 2013.

125. Marion County Probate Court records.

126. Harding Presidential Papers, Florence K. Harding Collection.

127. Harding Home "Fireside Chat" program.

128. Warwick, "The Course of True Love," in *Growing Up with Harding*.

129. Ibid.

130. Ibid.

131. *Marion County History*, 1907.

132. Harding Home Presidential Site.

133. Harding Home "Fireside Chat" program.

134. Cuneo, *From Printer to President*, 67.

135. Harding Presidential Papers, Ray Baker Harris Collection, Box 1.

136. Ibid., Box 2.

137. Warwick, "Mrs. Harding Joins 'the Force,'" in *Growing Up with Harding*.

138. Harding Presidential Papers, *Battle Creek Sanitarium* pamphlet.

139. *Marion County Directory*, 1890.

140. Harding Presidential Papers, *The American Bookmaker* pamphlet.

141. Harding Presidential Papers, Box 2.

142. *Marion Daily Star*, June 11, 1885.

143. Harding Presidential Papers, Box 2.

144. *Linotype: The Film*.

145. Harding Presidential Papers, Box 2.

146. Ibid.

147. Cuneo, *From Printer to President*, 14.

148. Harding Presidential Papers, Box 2.

149. Ibid.

CHAPTER 9

150. Chapple, *Warren G. Harding*, 23–24.

151. Russell, *Shadow of Blooming Grove*, 45.

152. Ibid., 46.

153. Harding Presidential Papers, Harold F. Alderfer PhD thesis, Syracuse University.

154. Ibid.

155. *Marion Daily Star*, August 28, 1885.

156. *Marion Weekly Star*, May 1, 1885.

157. Ibid.

158. Ibid., May 29, 1885.

159. Warwick, "Teaming It to Make Both Ends Meet."

160. Harding Presidential Papers, Box 2.

161. Dean, *Warren G. Harding*, 23.

162. Harding Presidential Papers, Box 2.

163. Chapple, *Warren G. Harding*, 75.

164. Harding Presidential Papers, Ohio Senate Biographical Annals, 346.

165. Ibid.

166. Dean, *Warren G. Harding*, 24.

167. Harding Presidential Papers, Box 45.

168. Warwick, "Getting by the Bumps," in *Growing Up with Harding*.

169. *Marion Daily Star*, January 13, 1947.

170. Harding Presidential Papers, Box 12.

171. Ibid.

172. Ibid., Box 46.

173. Cuneo, *From Printer to President*, 58.

174. Harding Presidential Papers, Box 46.

CHAPTER 10

175. Robenalt, *The Harding Affair*, intro.
176. Harding Presidential Papers, Box 54.
177. Robenalt, *The Harding Affair*, 39.
178. Ibid., 79.
179. Ibid.
180. Ibid.
181. Ibid., 113.
182. Ibid., 166.
183. Ibid., 350.

CHAPTER 11

184. Harding Presidential Papers, Kathleen Lawler Collection, Box 900.
185. Harding Presidential Papers, Box 24.
186. Ibid.
187. Ibid.
188. Ibid.
189. Ibid.
190. Ibid.
191. Ibid.
192. Ibid.
193. Ibid.
194. Ibid.
195. Ibid.
196. Ibid.
197. Ibid.
198. Ibid., Box 54.
199. Ibid., Box 1.

CHAPTER 12

200. Harding Presidential Papers, Box 851.
201. *Marion Daily Star*, July 6, 1920.
202. *Warren G. Harding, America's 29th President*.
203. Harding Presidential Papers, Kathleen Lawler Collection, Box 900.

204. Cuneo, *From Printer to President*, 102.

205. Harding Presidential Papers, Box 96.

206. Chapple, *Warren G. Harding*, 121.

207. Harding Presidential Papers, Box 96.

208. Cuneo, *From Printer to President*, 103.

209. Harding Presidential Papers, Kathleen Lawler Collection, Box 900.

210. Cuneo, *From Printer to President*, 103.

211. Harding Presidential Papers, Kathleen Lawler Collection, Box 900.

212. Ibid.

213. Harding Presidential Papers, Box 96.

214. *Mansfield (OH) Daily News*, November 3, 1920.

215. Cuneo, *From Printer to President*, 74–75.

216. *Marion Daily Star*, March 2, 1921.

217. Ibid.

CHAPTER 13

218. Harding Presidential Papers, Kathleen Lawler Collection, Box 900.

219. Harding Home Archives.

220. Ibid.

221. Chapple, *Warren G. Harding*, 170.

222. Harding Presidential Papers, Kathleen Lawler Collection, Box 900.

223. Murray, *The Harding Era*, 162.

224. Ibid., 167.

225. Ibid., 168.

226. Ibid., 169.

227. Ibid.

228. Chapple, *Warren G. Harding*, 172.

229. Harding Home Archives, Hoboken speech.

230. Murray, *The Harding Era*, 255.

231. Harding Home Archives, Birmingham speech.

232. Murray, *The Harding Era*, 429.

233. Ibid., 430.

234. Ibid.

235. *Marion Daily Star*, June 20, 1923.

236. Russell, *The Shadow of Blooming Grove*, 572.

237. Murphy, *Speeches and Addresses of Warren G. Harding*, survey of speeches.

238. Cuneo, *From Printer to President*, 61.

CHAPTER 14

239. Harding, Warren G. Harding Symposium.
240. Heller, *The Presidents' Doctor*, 62.
241. Harding, Warren G. Harding Symposium.
242. *Marion Daily Star*, August 3, 1923.
243. Ibid., August 11, 1923.
244. Ibid., August 3, 1923.

EPILOGUE

245. *Marion Daily Star*, May 8–11, 1925.
246. Ibid., August 26, 1967.
247. Ibid., April 30, 1968.
248. 1910, 1920 U.S. censuses; *Marion Daily Star*, January 24, 1927.
249. 1910, 1920 U.S. censuses; *Marion Daily Star*, March 22, 1921.
250. 1880, 1900, 1910, 1920, 1930 U.S. censuses; *Marion Daily Star*, January 13, 1947.
251. 1870, 1880, 1900, 1910, 1920 U.S. censuses; *Marion Daily Star*, February 15, 1953.
252. 1880, 1900, 1910, 1920, 1930 U.S. censuses; *Marion Daily Star*, March 27, 1932.
253. 1880, 1900, 1910, 1920, 1930 U.S. censuses; *Marion Daily Star*, August 22, 1935.
254. *Marion Daily Star*, May 5, 1925.

Bibliography

Anthony, Carl Sferrazza. *Florence Harding: The First Lady, the Jazz Age, and the Death of American's Most Scandalous President.* New York: William Morrow and Co., 1998.

Chapple, Joe Mitchell. *Warren G. Harding, Our After-War President.* Boston: Chapple Publishing Co., 1924.

Cuneo, Sherman A. *From Printer to President: The Story of Warren G. Harding.* Philadelphia: Dorrance & Co., 1922.

Dean, John. *Warren G. Harding.* New York: Times Books, Henry Holt and Co., 2004.

Harding, Dr. Richard, Professor and Chair, Department of Neuropsychiatry and Behavioral Science. University of South Carolina School of Medicine.

Harding Home "Fireside Chat" program, 2013.

Harding Home Presidential Site, Marion, Ohio.

Heller, Milton F., Jr. *The Presidents' Doctor: An Insider's View of Three First Families.* New York: Vantage Press, 2000.

History of Marion County, Ohio. Chicago: Leggett, Conaway & Co. 1883.

Jacoby, J. Wilbur, ed. and comp. *History of Marion County, Ohio and Representative Citizens.* Chicago: Biographical Publishing Company, 1907.

Johnson, Willis Fletcher. *The Life of Warren G. Harding: From the Simple Life of the Farm to the Glamour and Power of the White House.* N.p., 1923.

Linotype: The Film, In Search of the Eighth Wonder of the World. Film. Produced and directed by Douglas Wilson. 2012.

Marion City Directory, 1882, 1889, 1890–91. Marion Public Library.

Marion County Probate Court records. Marion County Building.

Marion Daily Star

Marion Democratic Mirror

Marion Independent

Marion Weekly Star

Murphy, James W., comp. *Speeches and Addresses of Warren G. Harding, President of the United States, Delivered During the Course of His Tour from Washington, D.C., to Alaska and Return to San Francisco, June 20 to August 2, 1923*. Washington, D.C.: published under the patronage of President Calvin Coolidge, Chief Justice William H. Taft, cabinet members, et al, 1923.

Murray, Robert K. *The Harding Era: Warren G. Harding and His Administration*. Newtown, CT: American Political Biography Press, 1969. Reprint, 2000.

Robenalt, James David. *The Harding Affair: Love and Espionage During the Great War*. New York: Palgrave Macmillan, 2009.

Romine, Trella Hemmerly. *History of the Marion County Courthouse*. Marion, OH: Marion County Centennial Committee, 1984.

Russell, Francis. *The Shadow of Blooming Grove: Warren G. Harding in His Times*. New York: McGraw-Hill Book Co., 1968.

Sullivan, Mark. *Our Times: The Twenties*. New York: Charles Scribner's Sons, 1935.

U.S. census reports, 1880–1940. *www.ancestry.com*.

Warren G. Harding, America's 29th President. Film. Dover, OH: Tarulli Video Productions, 2011.

Warren G. Harding Presidential Papers. Ohio History Connection Archives, Columbus, OH.

Warwick, Jack. *Growing Up with Warren Harding*. Reprinted from *All in a Lifetime*. N.p.: self-published, 1938.

Index

About the Author

Sheryl (Sherry) Smart Hall was a city hall and police reporter, as well as the Sunday edition editor at the *Marion Star* and a copyeditor and bureau chief at the Canton (Ohio) Repository before accepting her current position at the Harding Home Presidential Site in Marion. She served as the site's education coordinator for nine years and then assumed the job of site manager in 2009. A native of Marion, she graduated from Heidelberg University with majors in English and American studies.